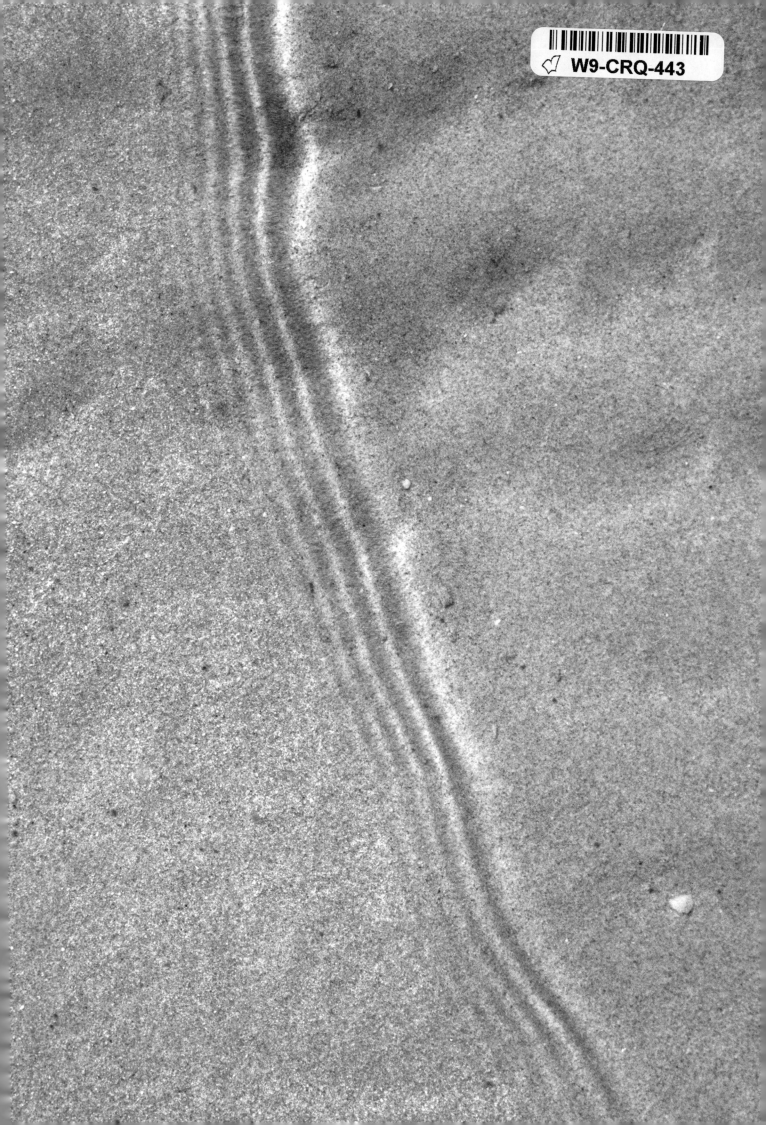

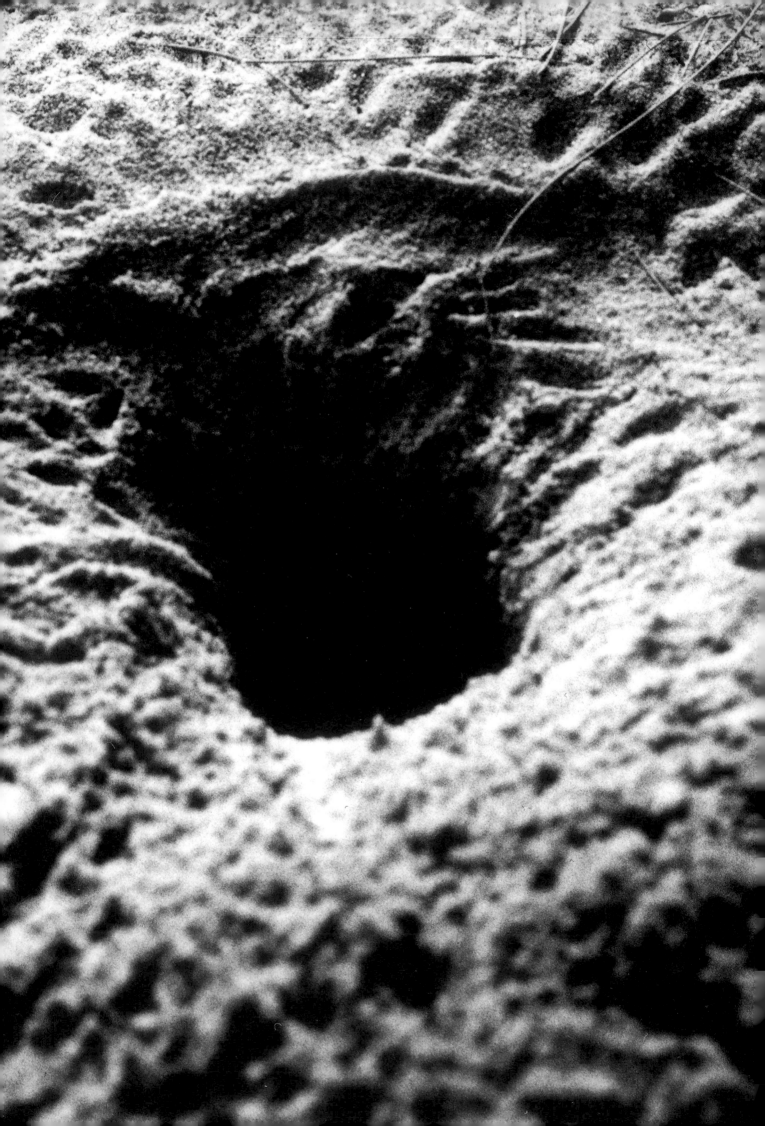

the beach was their territory. sometimes a whole p
pack would follow me, but mostly keeping their distance.
they spent their time sleeping, chasing crabs, cockroaches
and tourists or fighting with each other. at night they could
turn nasty and attack you from out of the dark. they stole my
shoes and chewed them up.

the dogs were always acting up, for food; for affection.
one dog swam after me giving a heartbreaking performance of
drowning before giving up and swimming back to the beach.

tiger was the only dog that seemed to have a name. crippled,
his legs looked like they were made of grisly rubber. his walk,
a pityful waddle. he enjoyed the generous protection of the
half chinese buddhist cook. his batears were too big and his snout
too long for his head. mostly the other dogs left him alone.
sometimes they brought him cockroaches to play with.

printed om munken pure, 170g. munkedals AB, sweden.
www.munkedals.se

published by kruse verlag, hamburg, germany. scans and repro-
duction by reproduktion onnen & klein, hamburg. printed by: druck
erei weidmann, hamburg. bookdesign by suse uhlenbrock. photo-
graphs copyright © 2000 suse uhlenbrock. this edition copyright © 2000 kruse
verlag. no part of this book may be reproduced without the written permission
of the publisher.

Kruse Verlag: Kampstrasse 11, 20357 hamburg, GERMANY
phone: 0049 40 4328246-0, fax: 0049 40 4328246-12.
e-mail:info@KrusePublishers.com www.KrusePublishers.com

distribution in north, south, and central america, asia, australia and
africa by D.A.P./Distributed Art Publishers, 155 sixth avenue, 2nd floor,
new york N.Y. 1001001 3. phone: 001 212 627 1999, fax: 001 212 6279484.

distribution in europe, asia, australia and africa by IDEA books,
nieuwe herengracht 11, 1011 RHK amsterdam, NETHERLANDS.
fax:0031 20 6209299. e-mail:idea@ideabooks.nl

distribution in germany, austria and switzerland by kruse verlag
first kruse verlag edition, 2000.
printed in germany.

isbn 3-934923-05-4

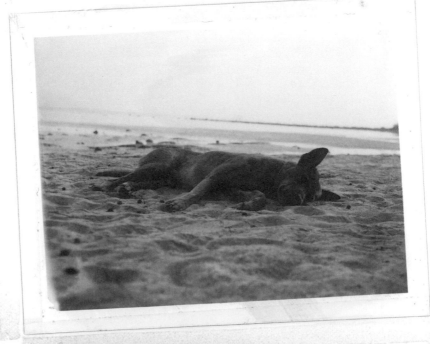

Joey ● hugs the vicious circle of happiness.
~~(between them)~~

Zoey hugs the moon.

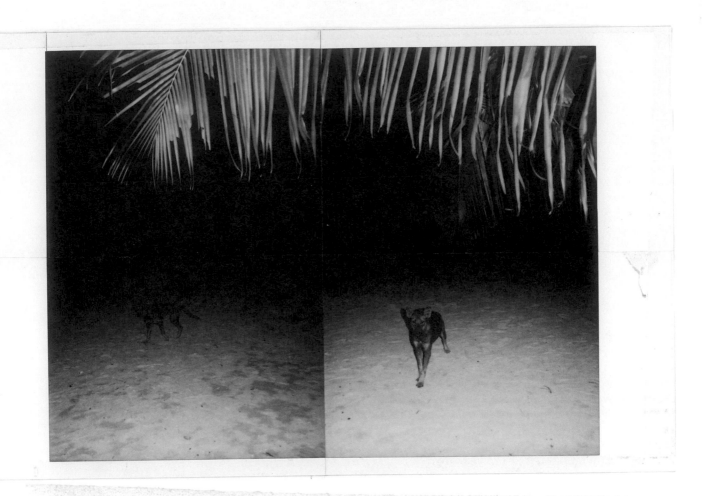

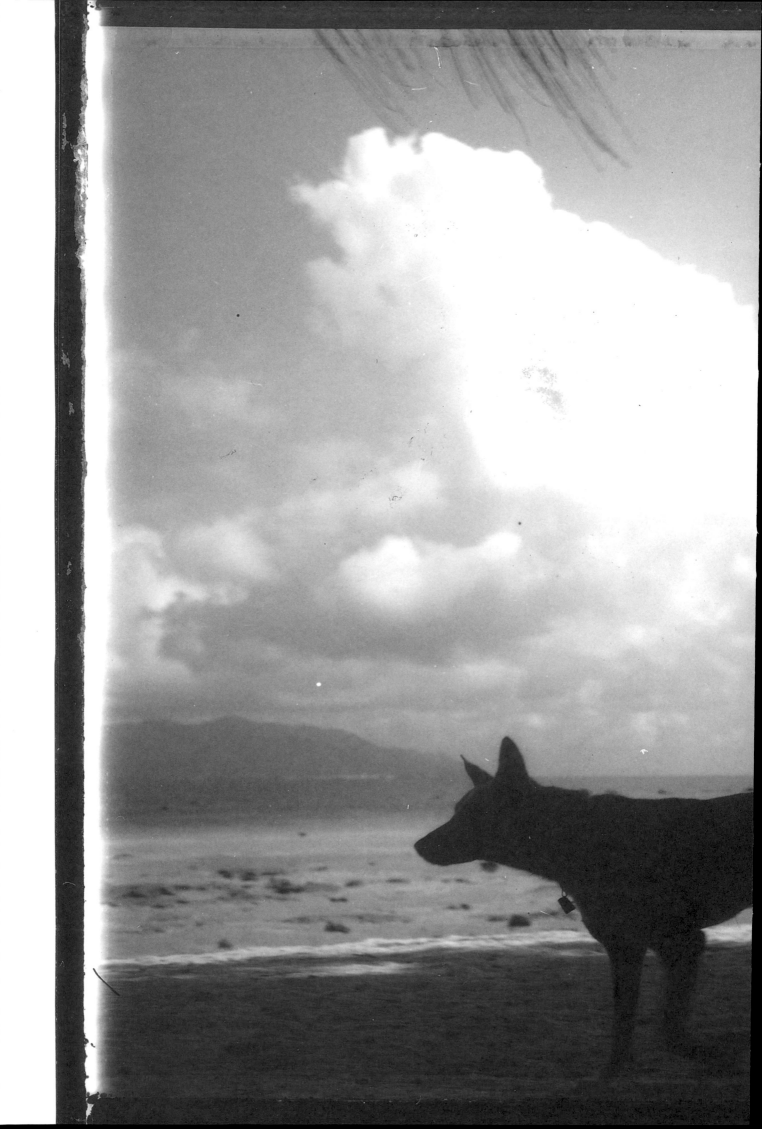

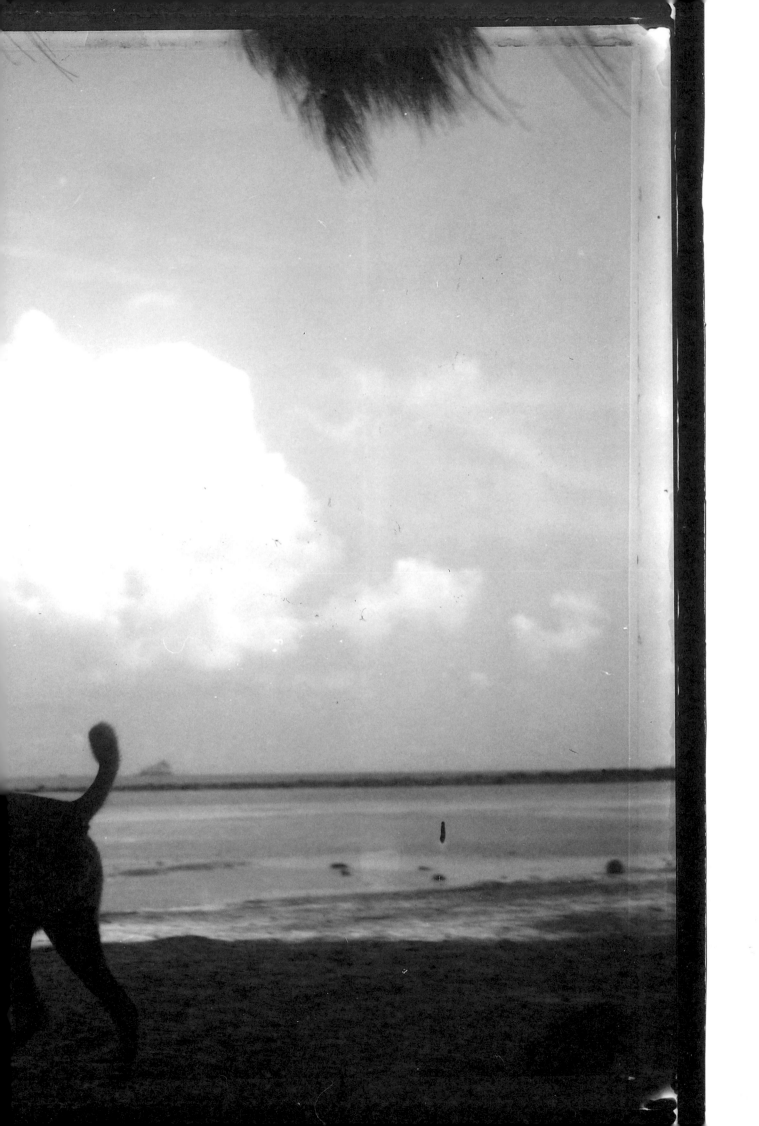

DAY 1

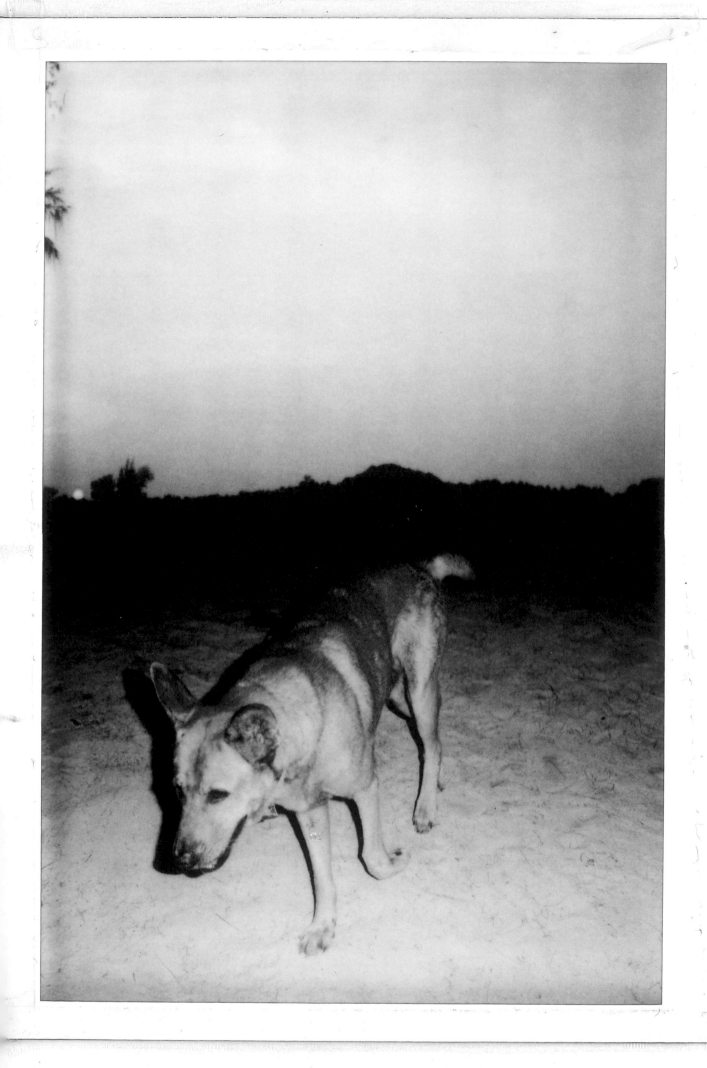

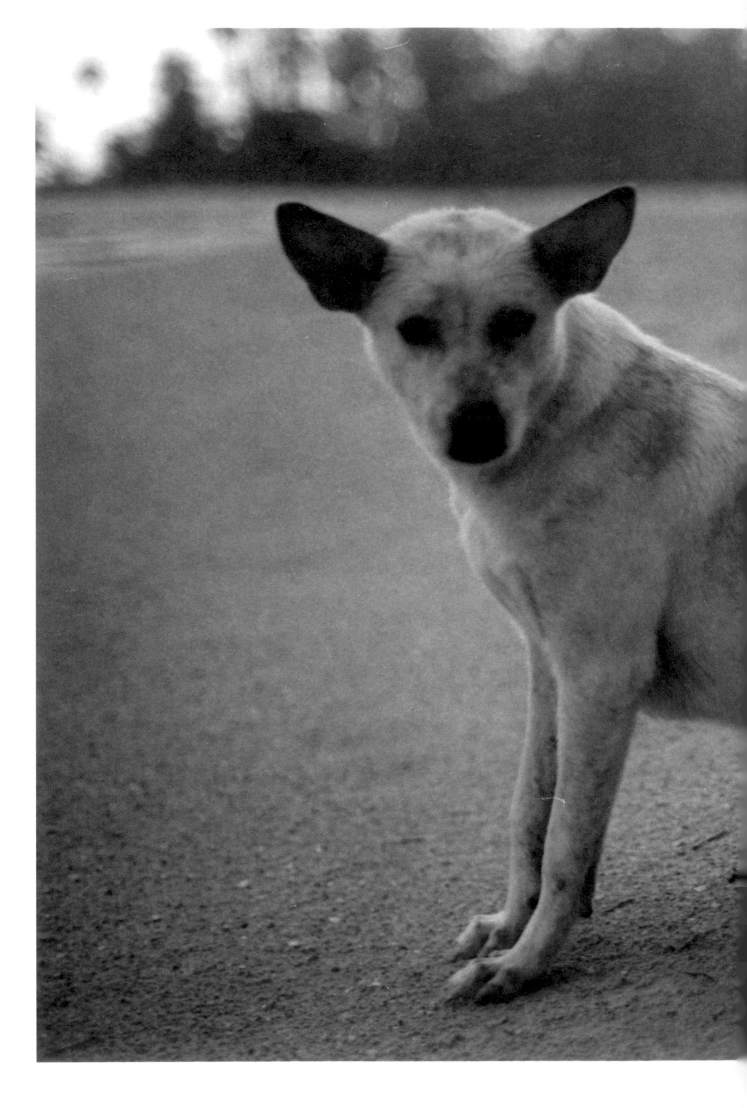

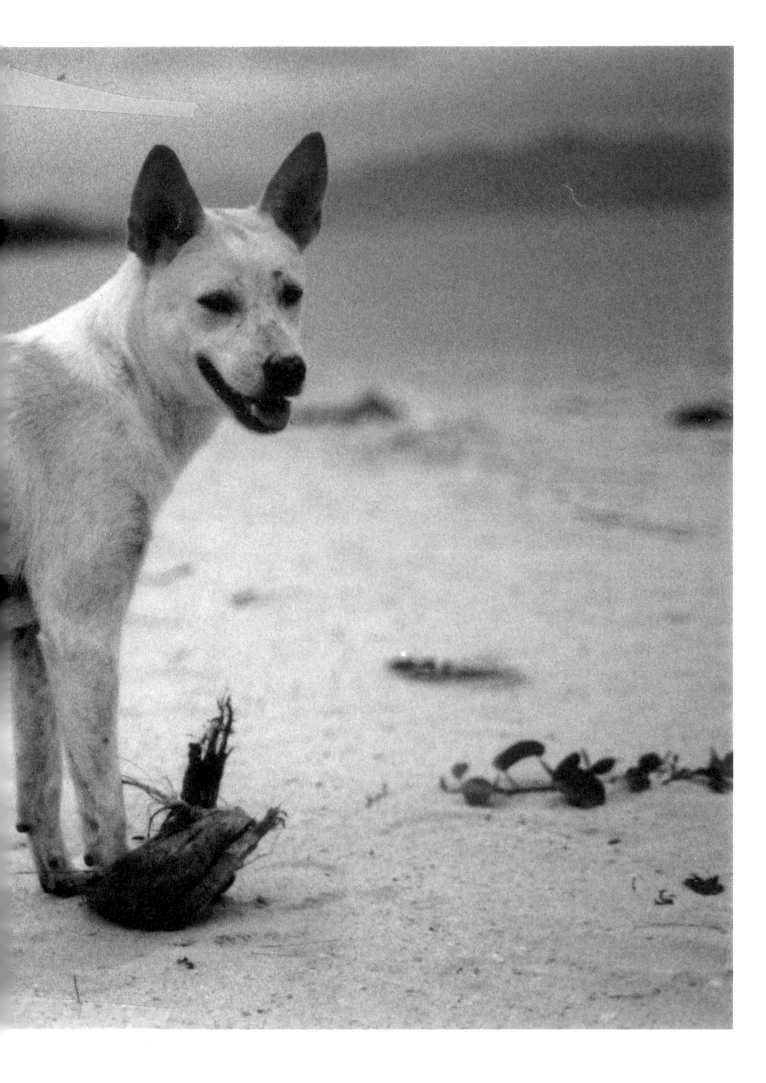

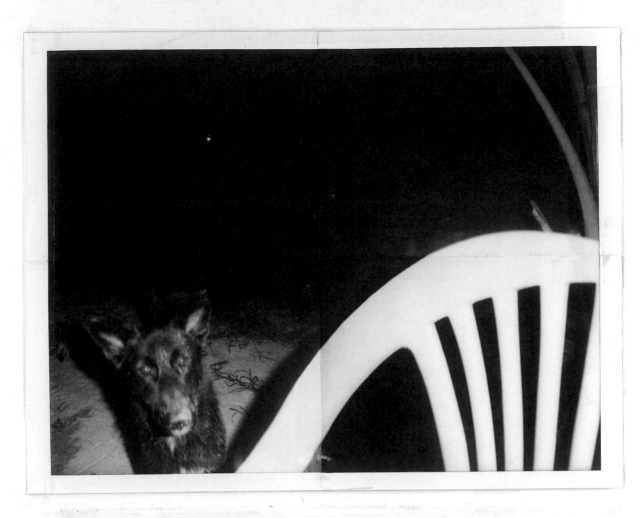

— what would you like?
— a tuna sandwhich, please.
— one tuna sandwhich?
— ah..., ah, no, seven please!

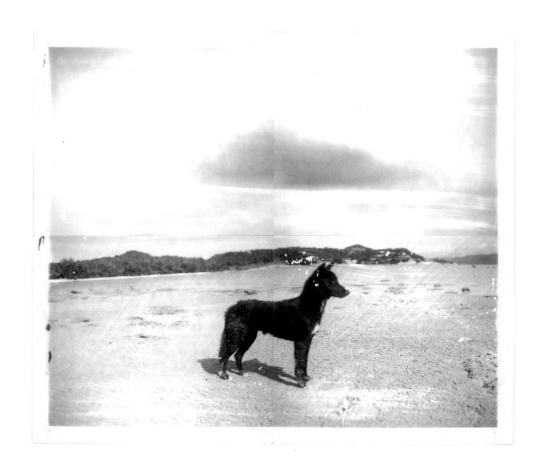

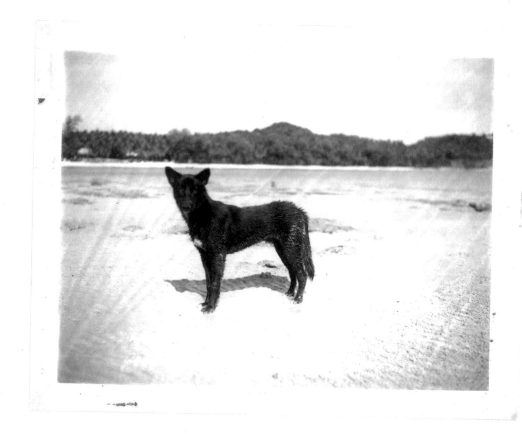

Island view

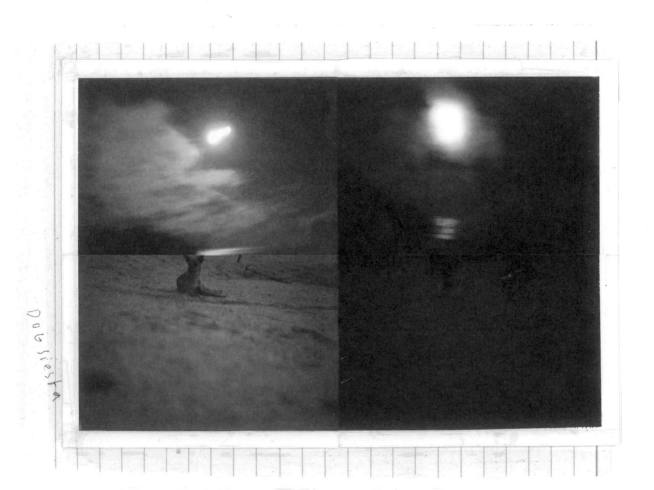

Dog siesta

DAY 2

LONG SLEEPY
LING MONKEY
LAP WIND

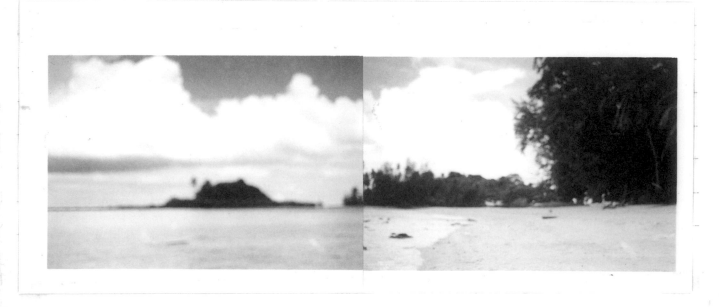

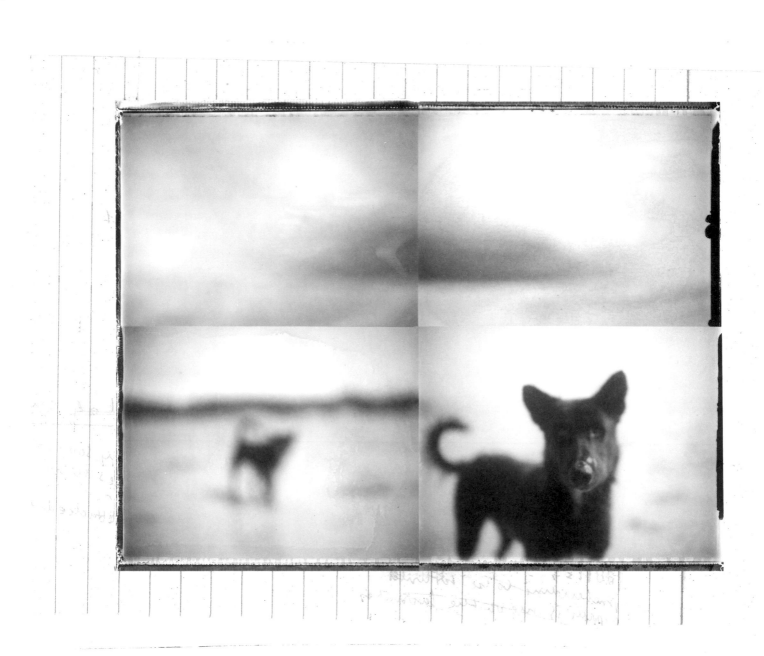

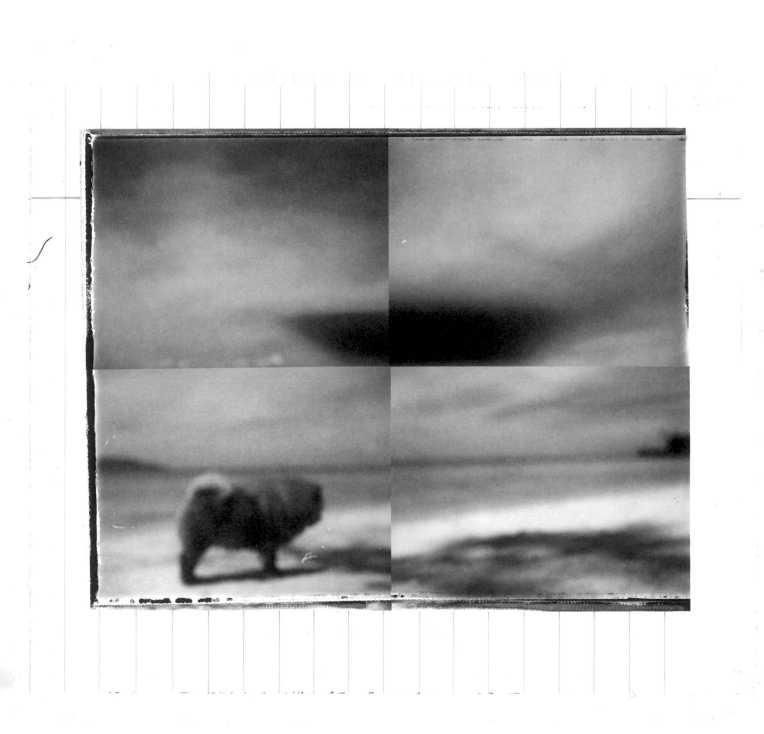

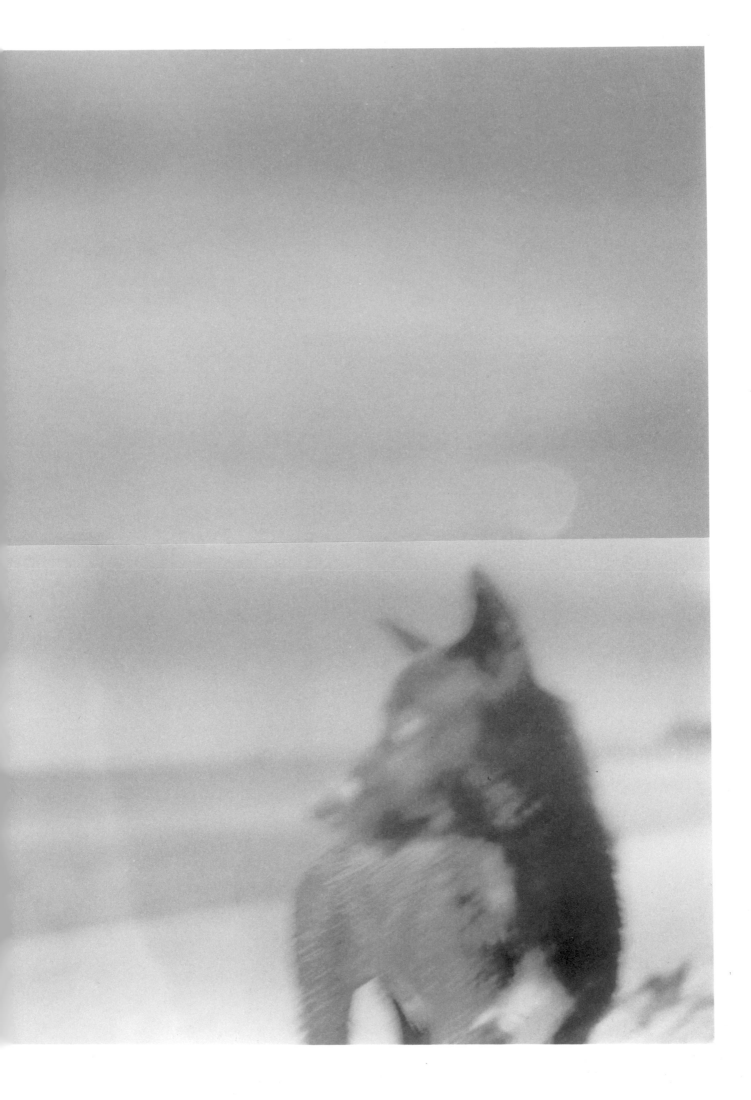

The FIGHT:

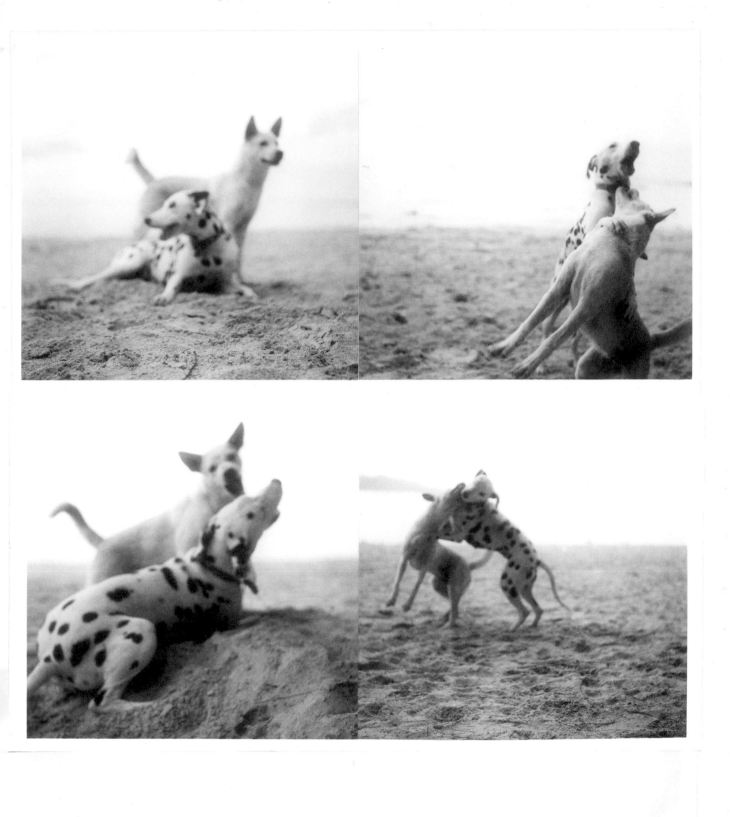
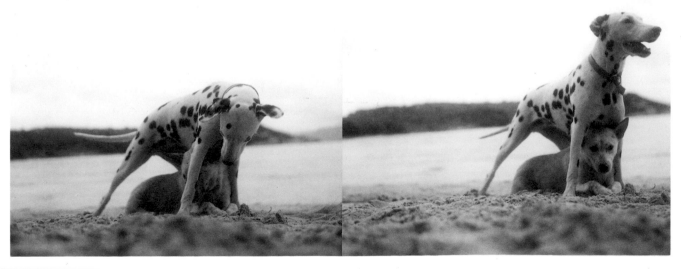

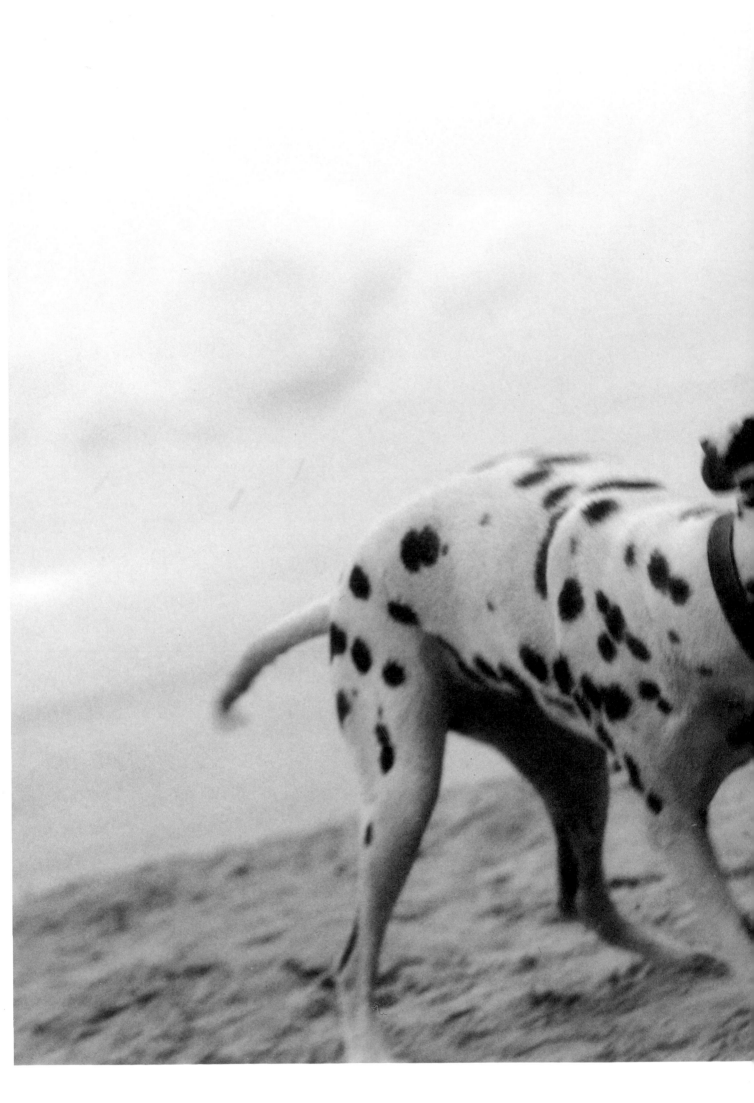

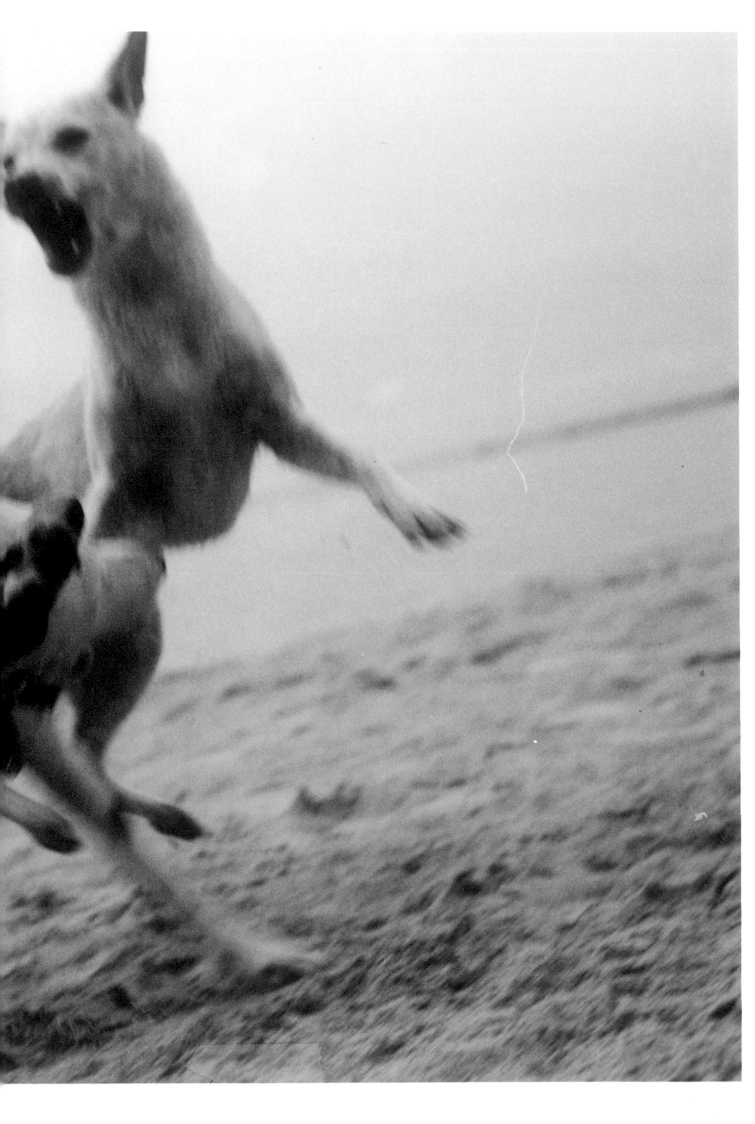

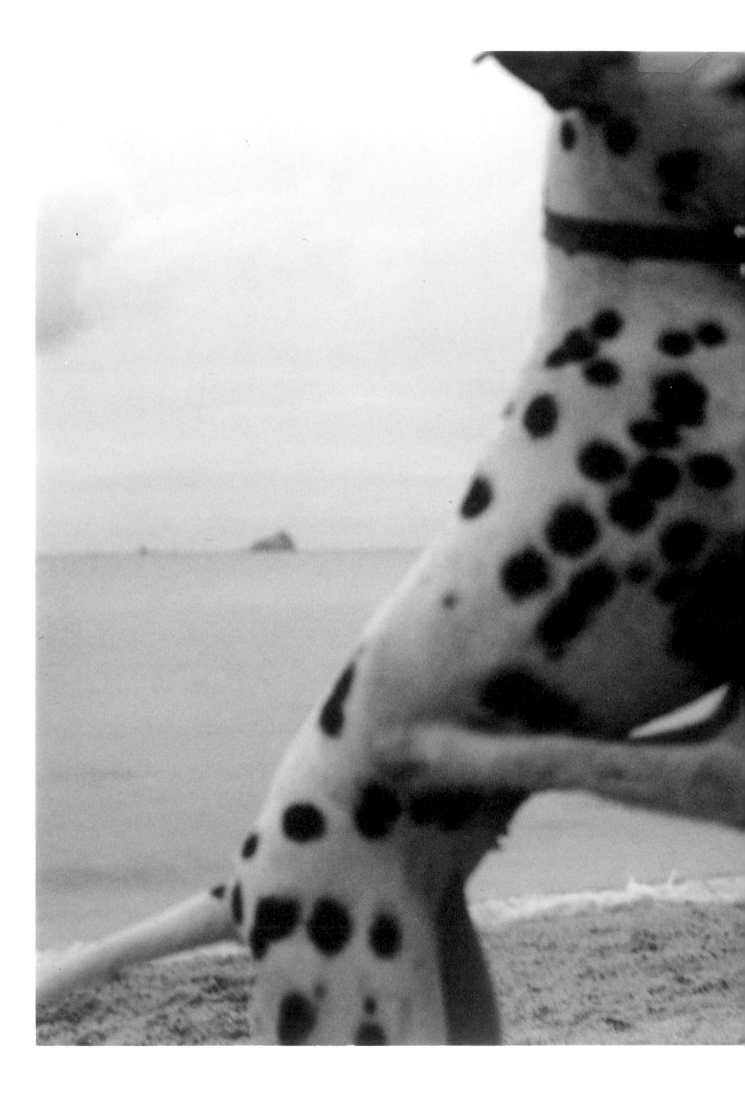

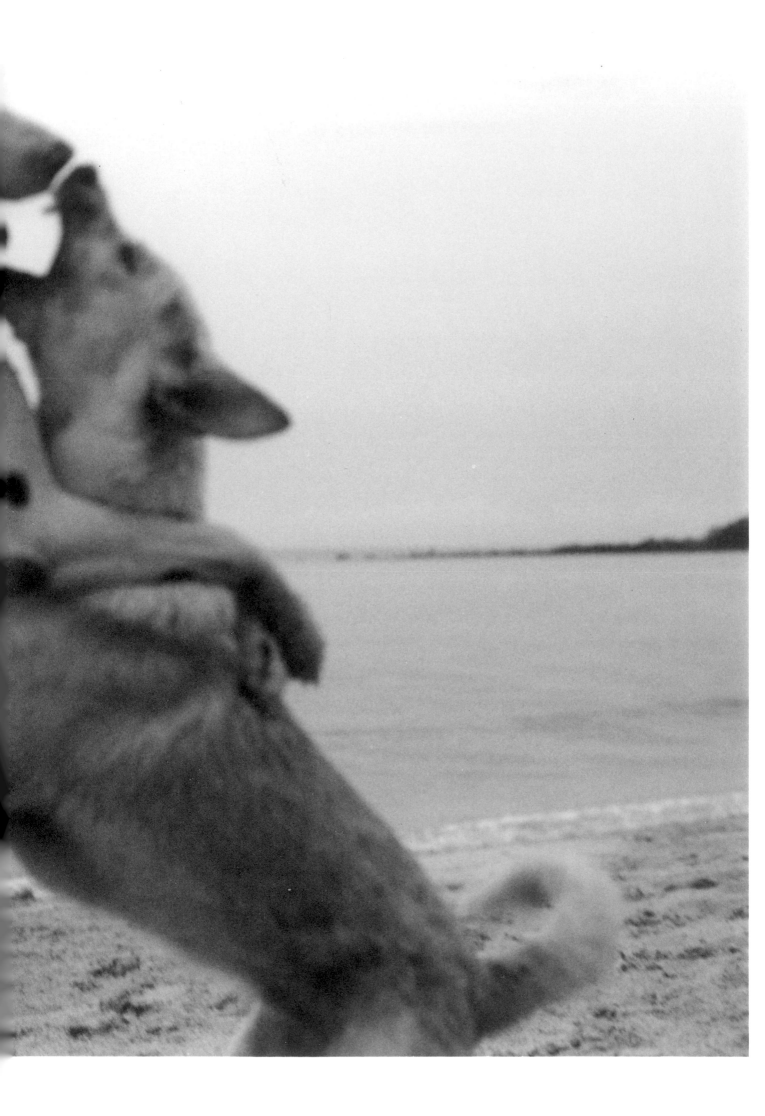

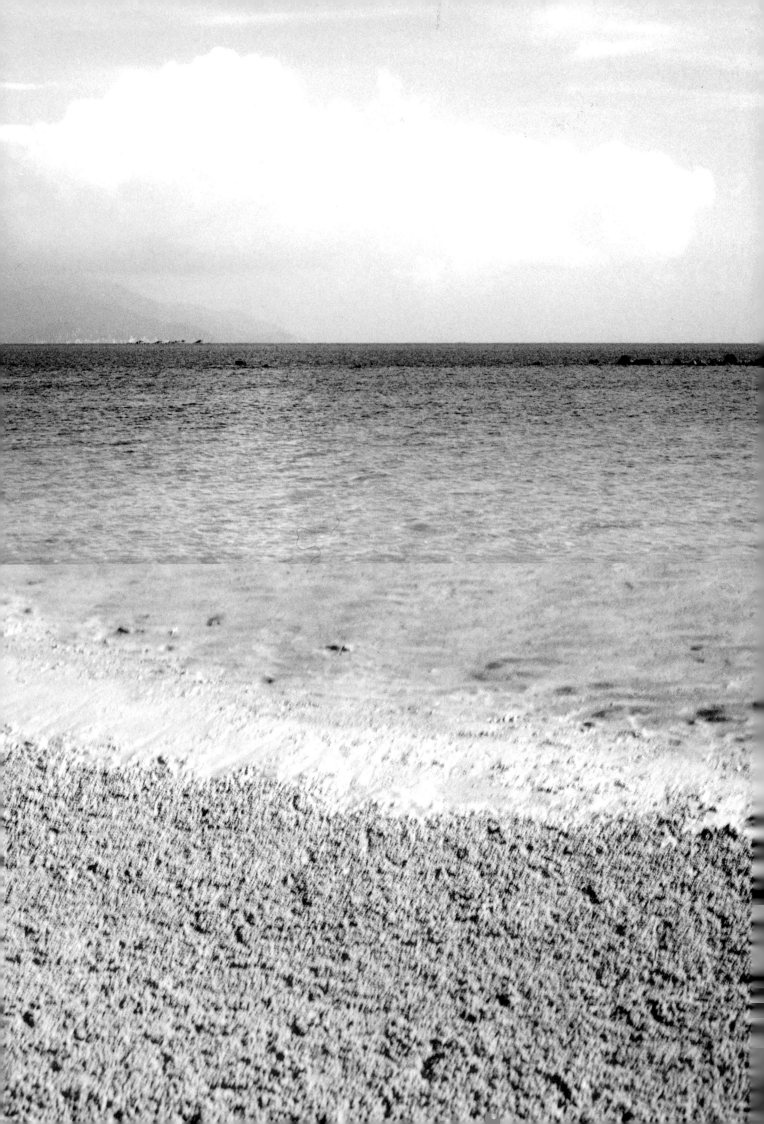

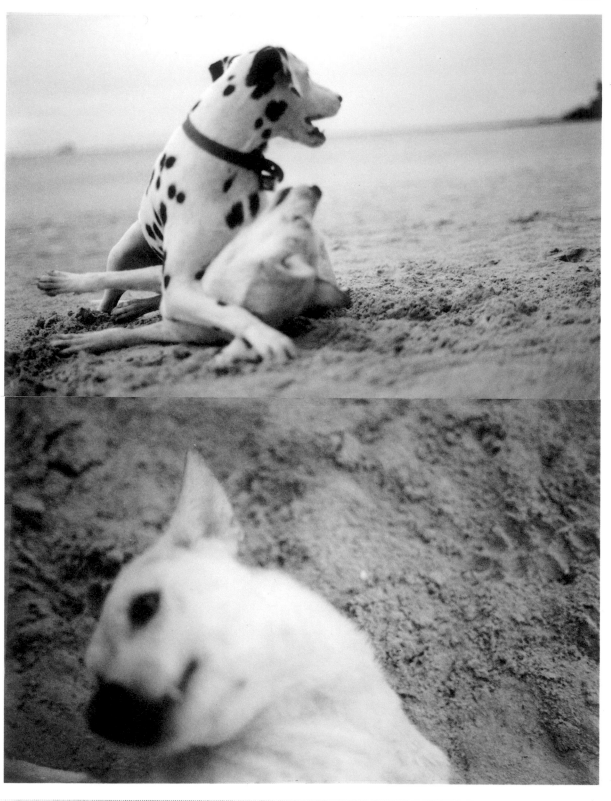

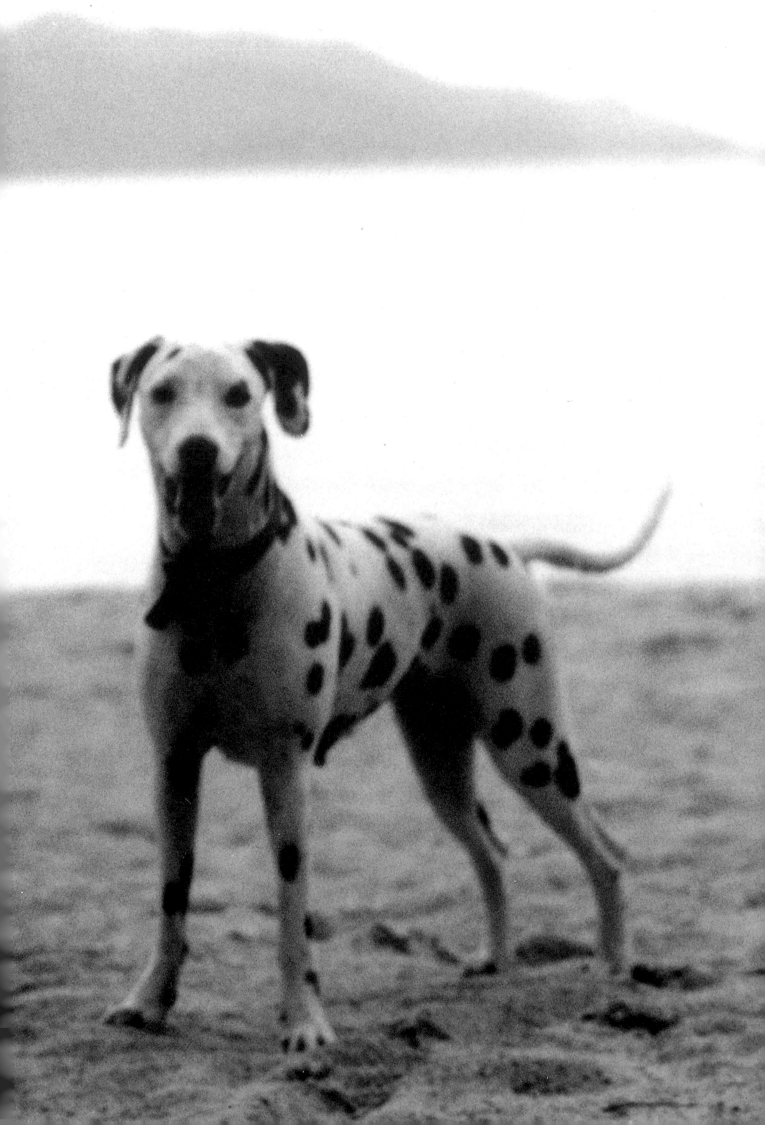

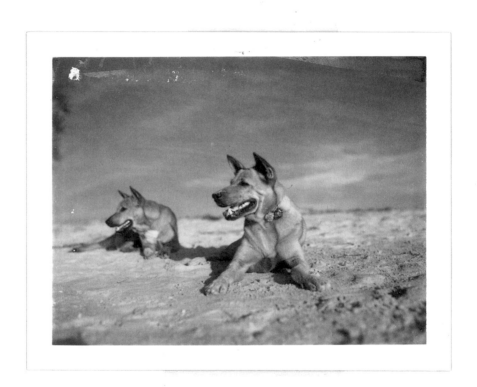

DAY 6

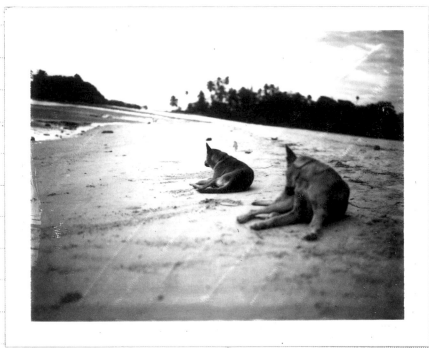

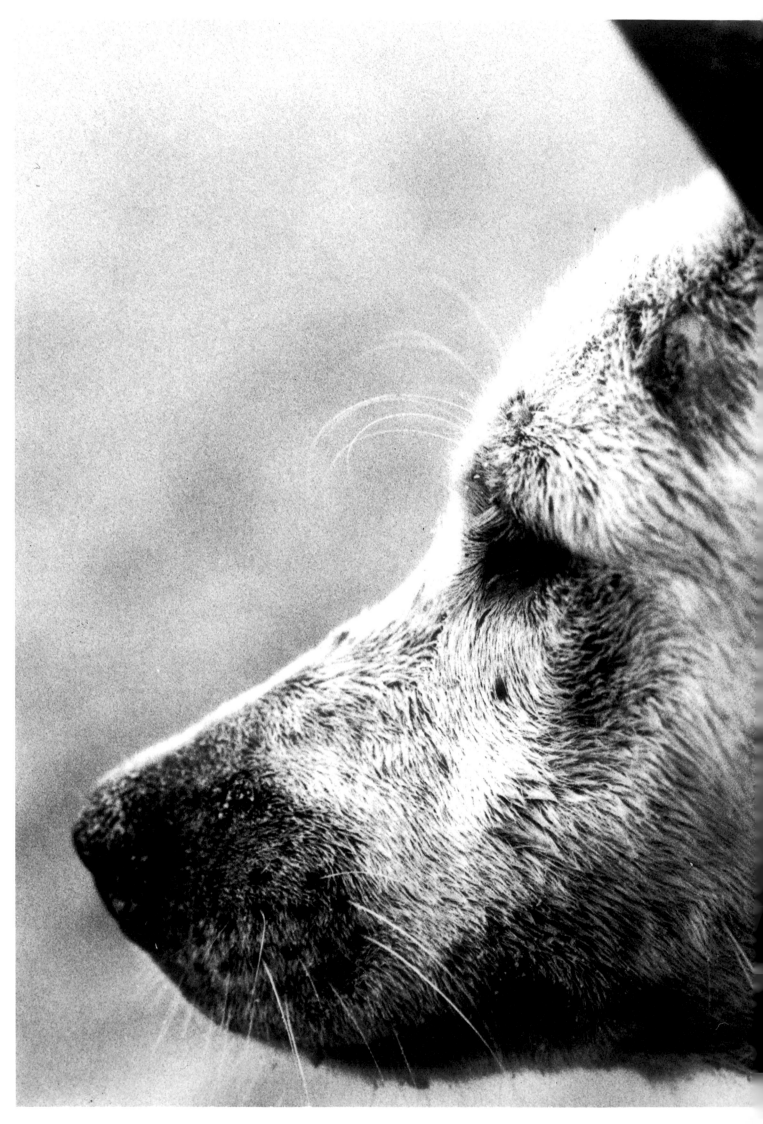

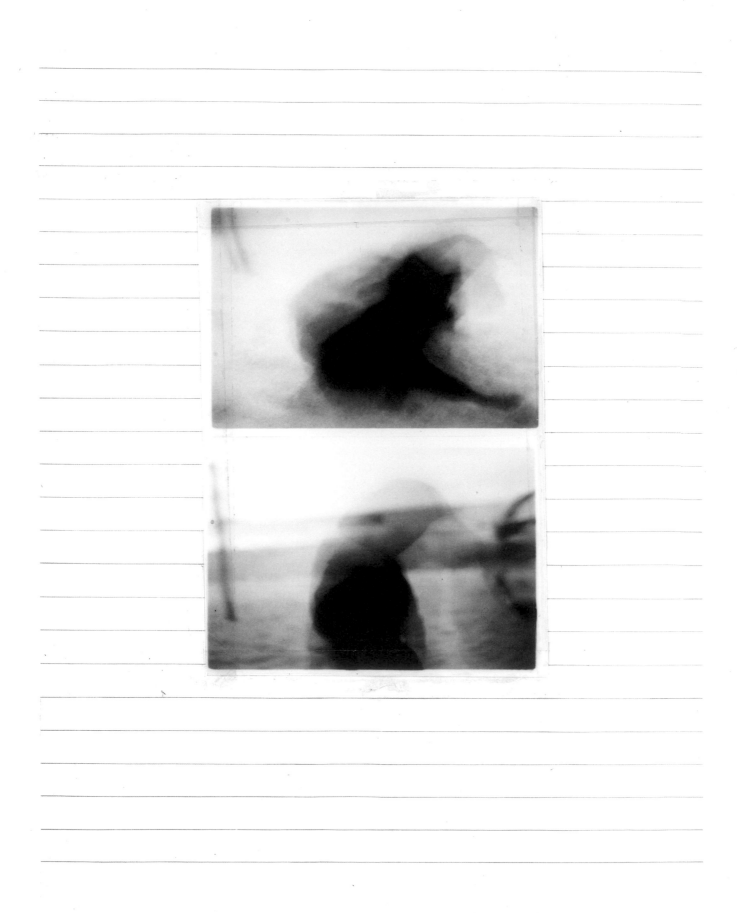

DOG DAZE

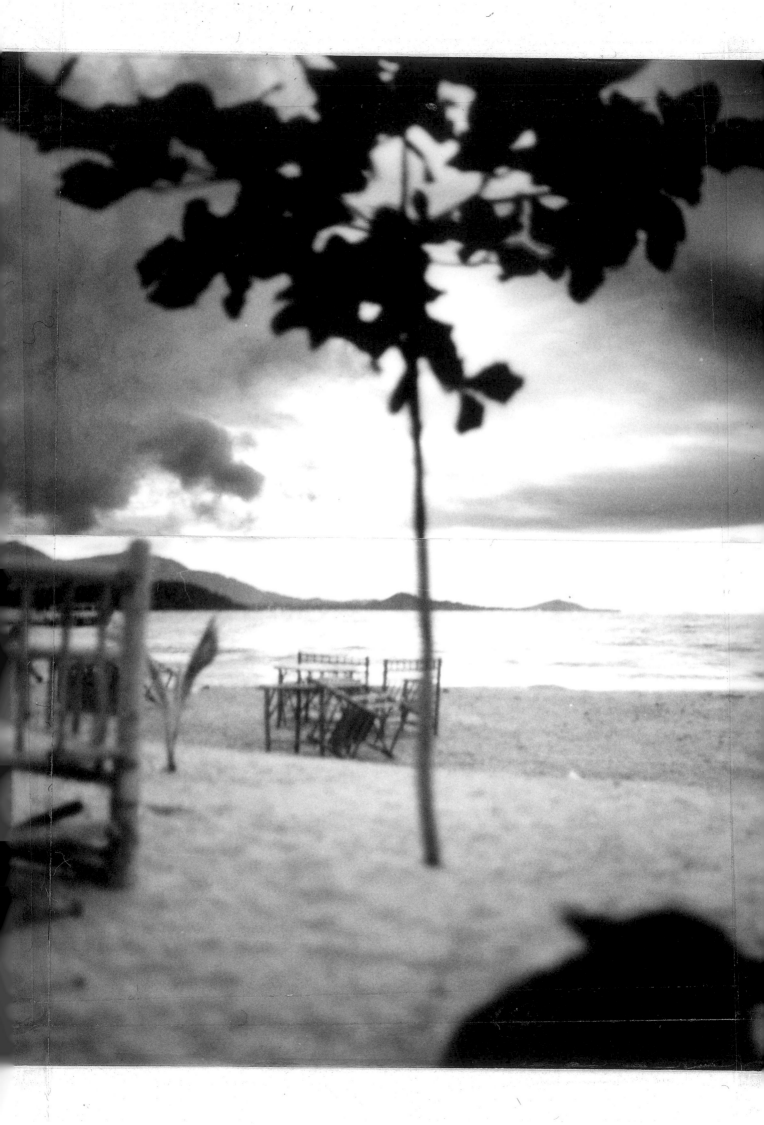

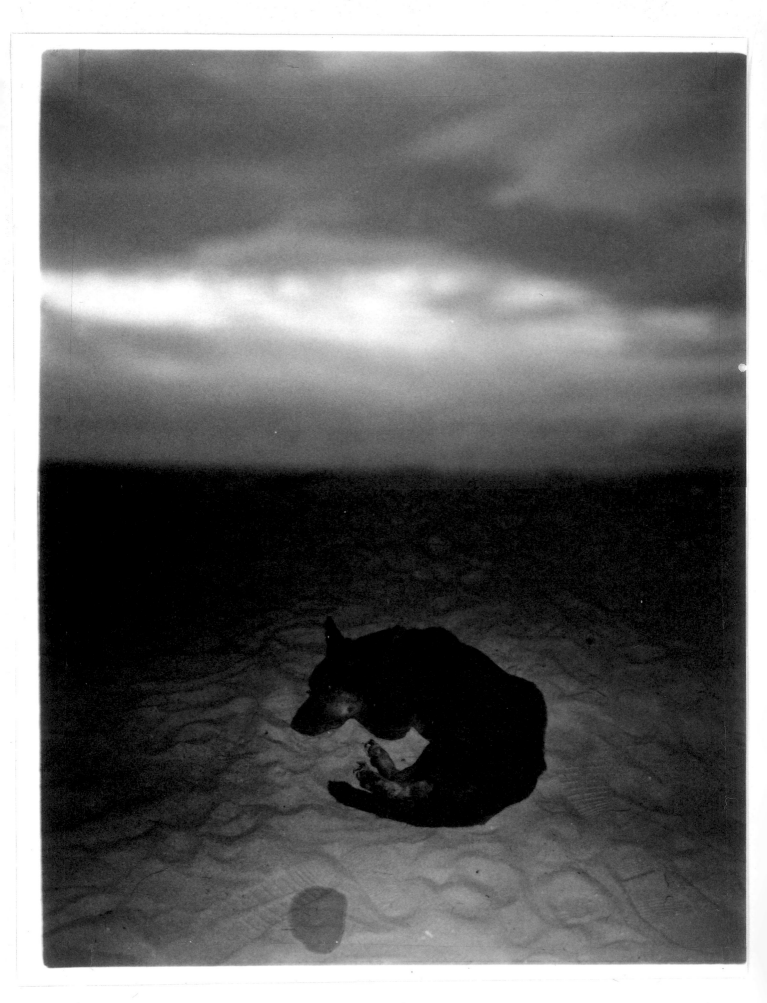

TIGER

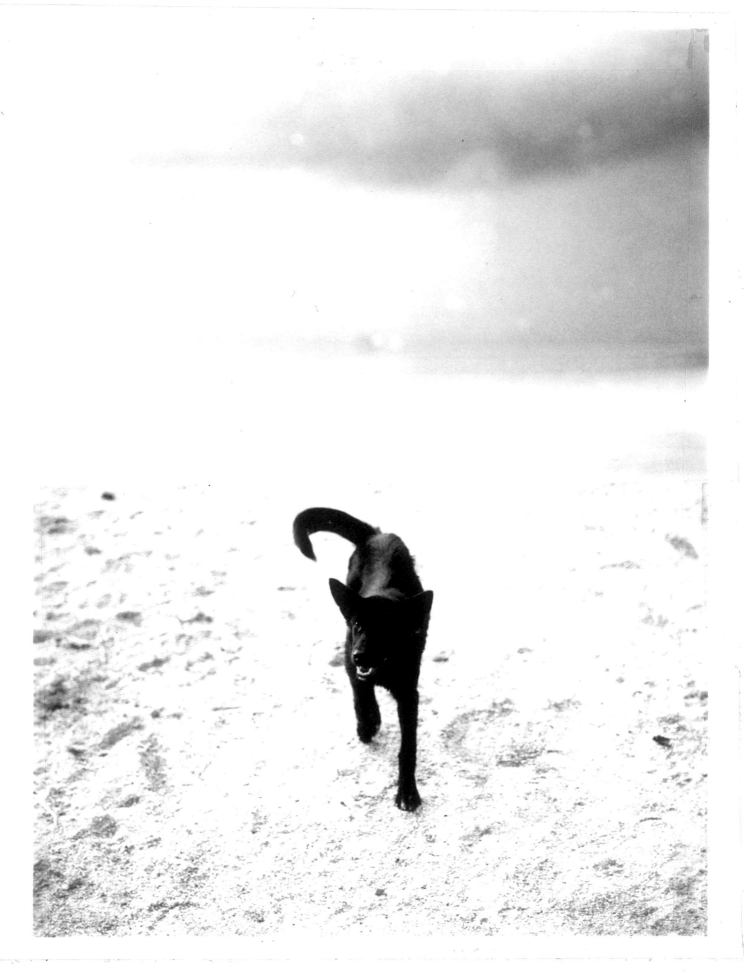

No Name

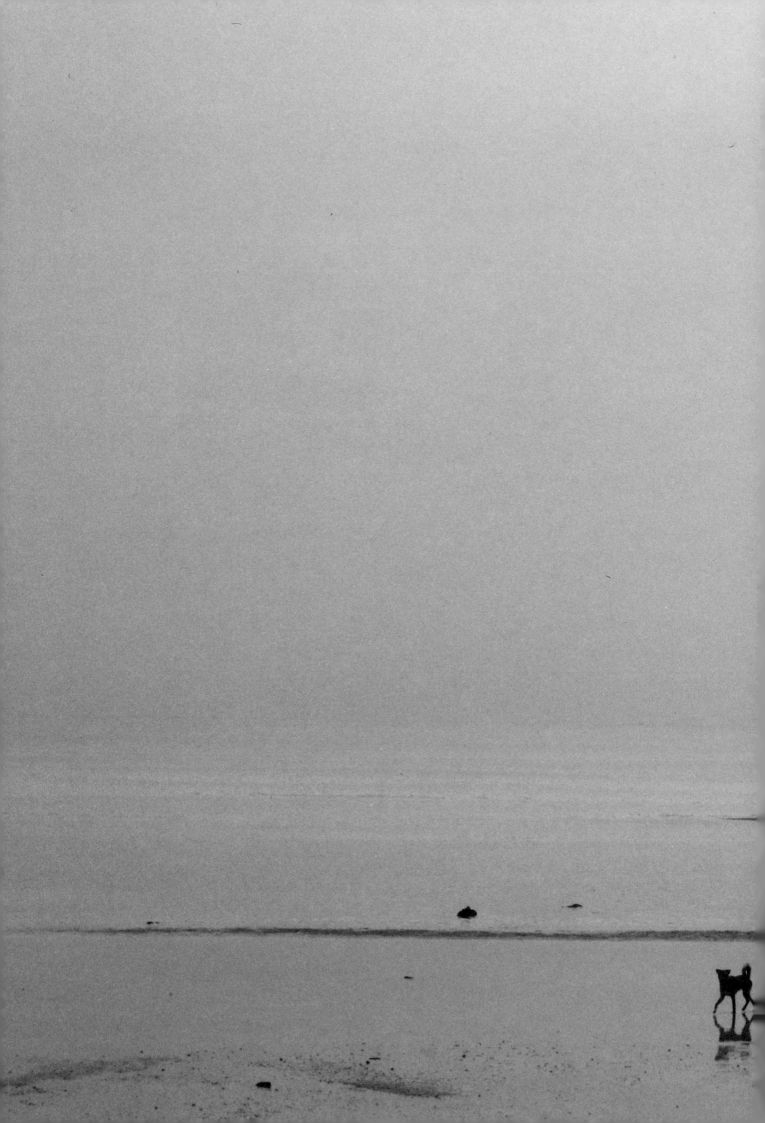

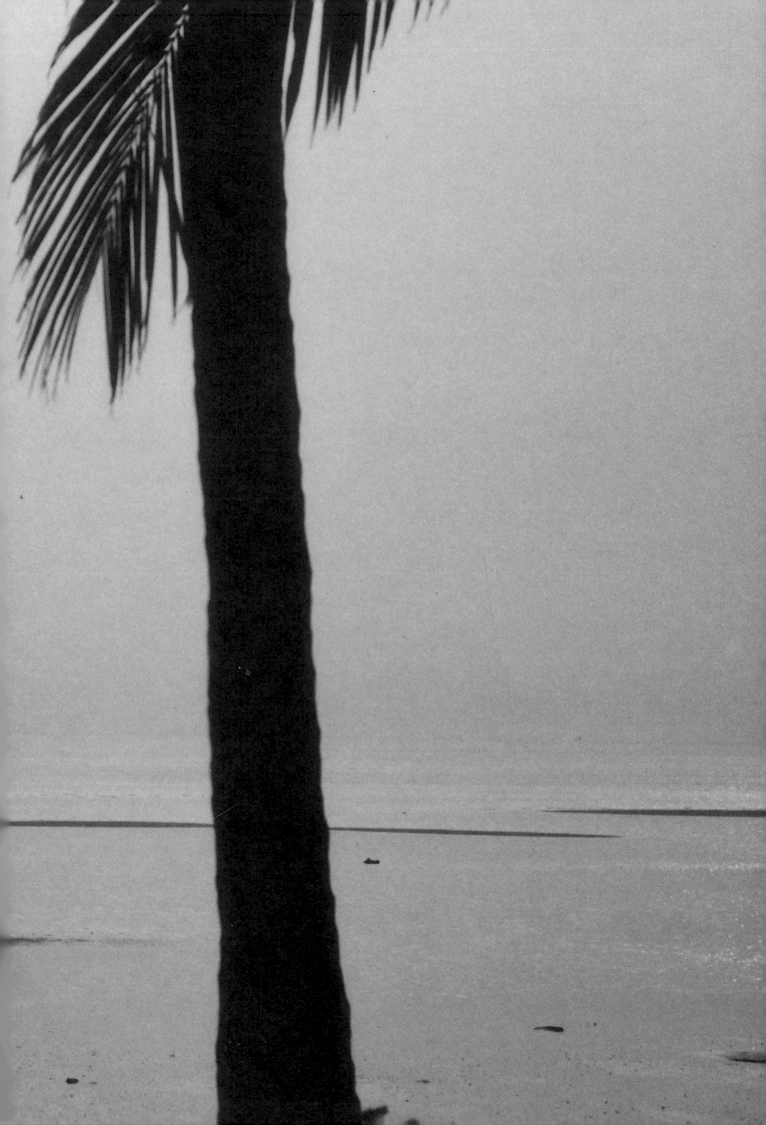

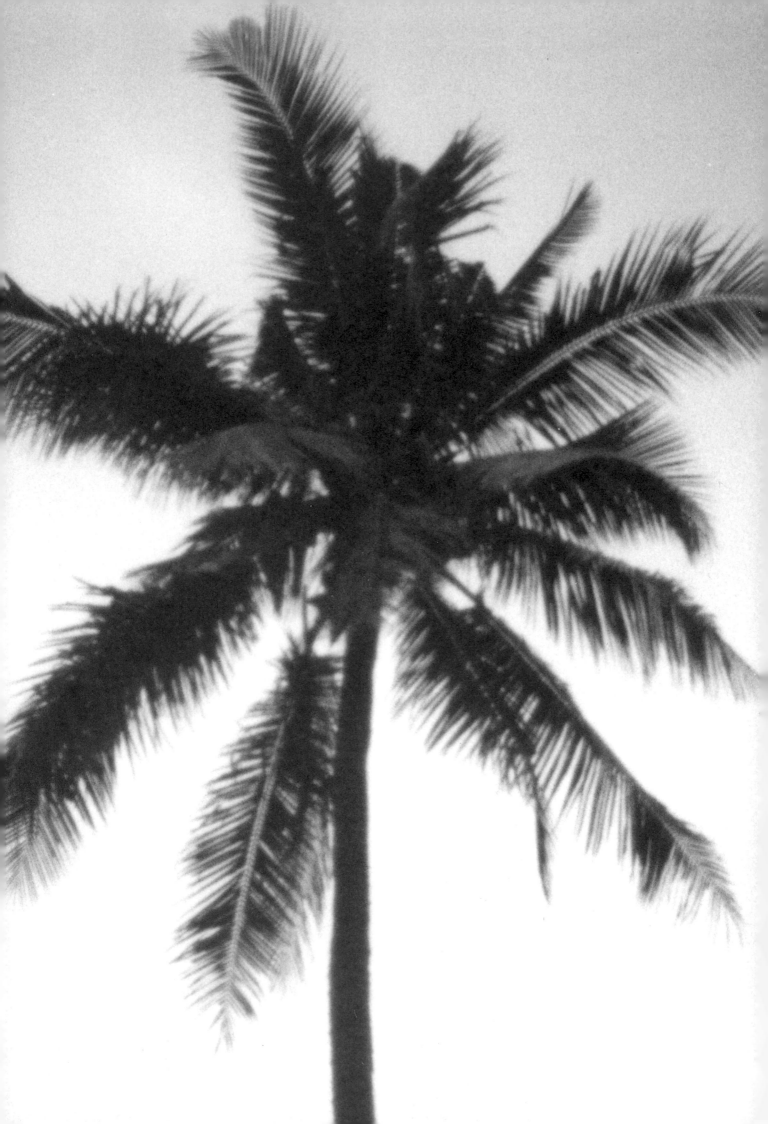

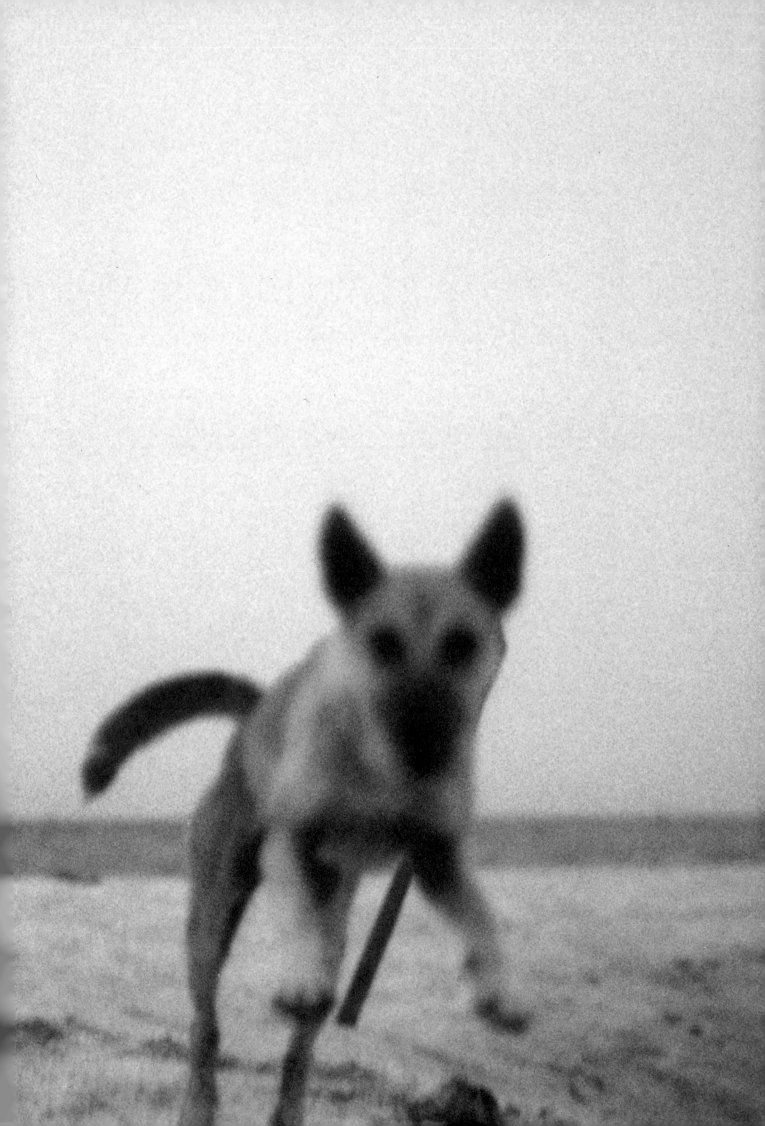

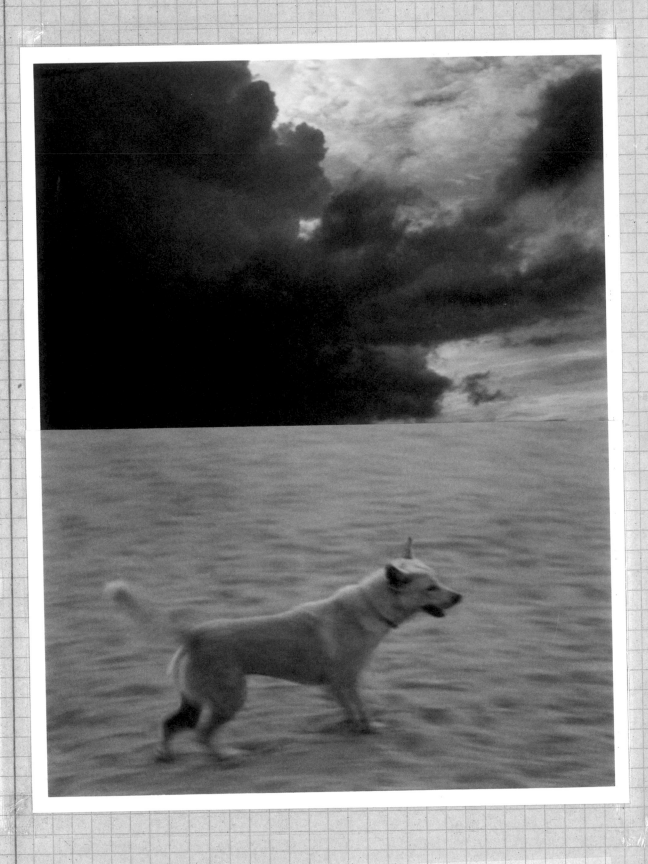

CLOUDY

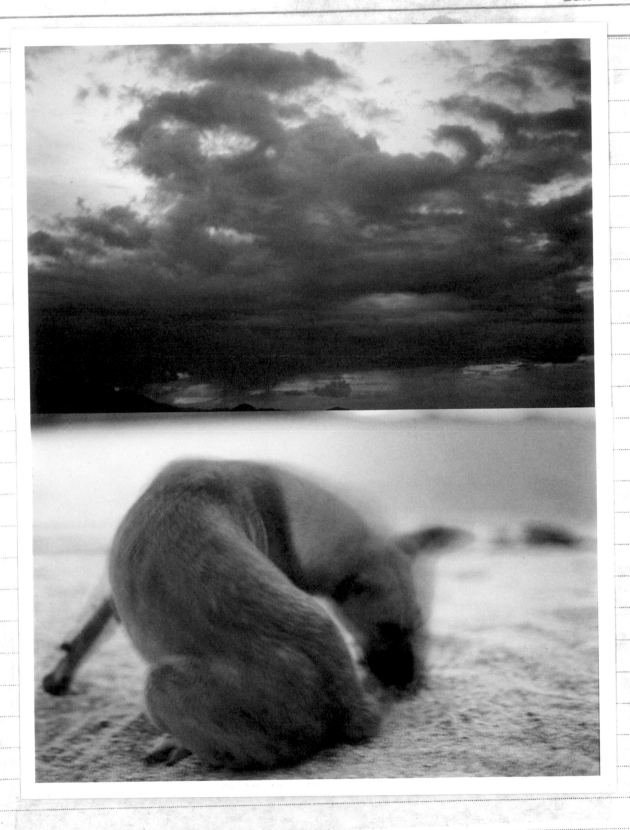

Rain in the afternoon

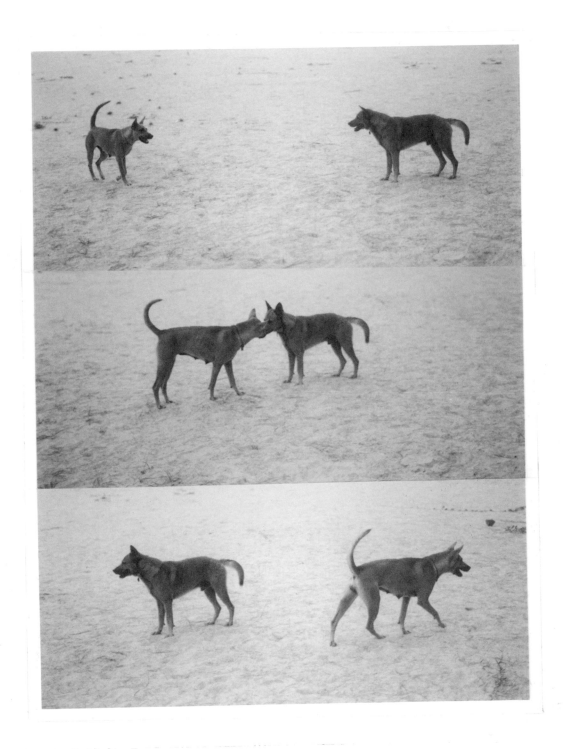

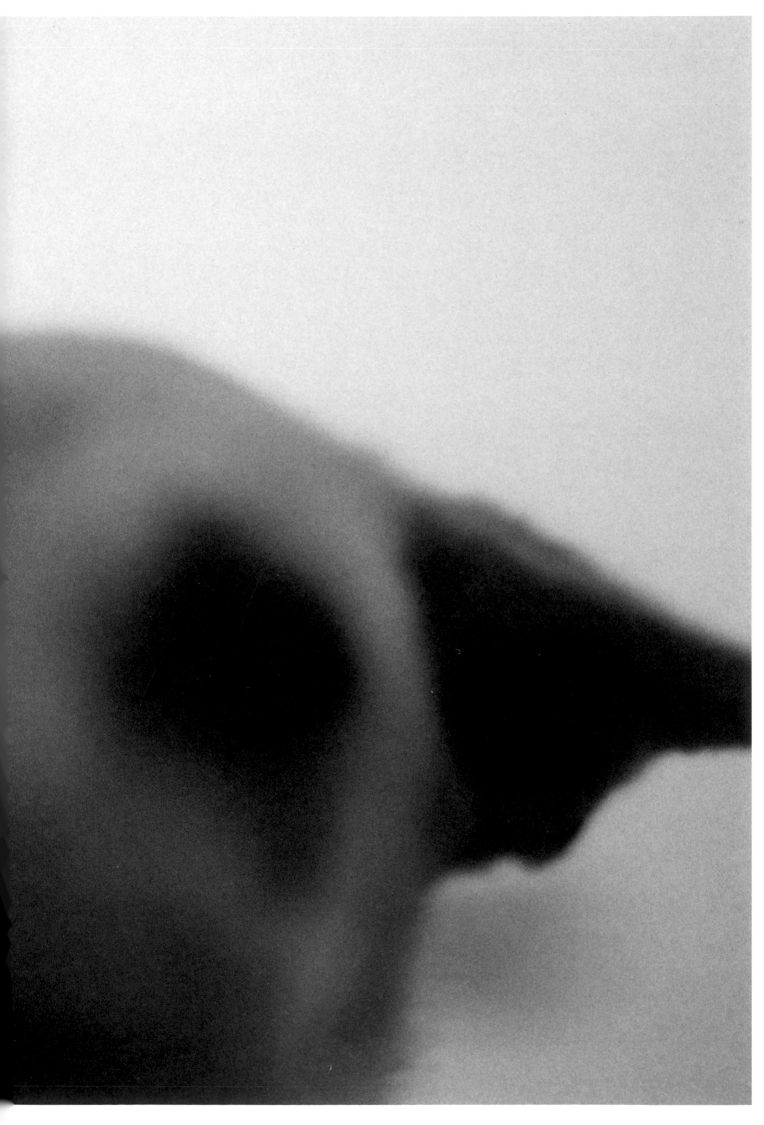

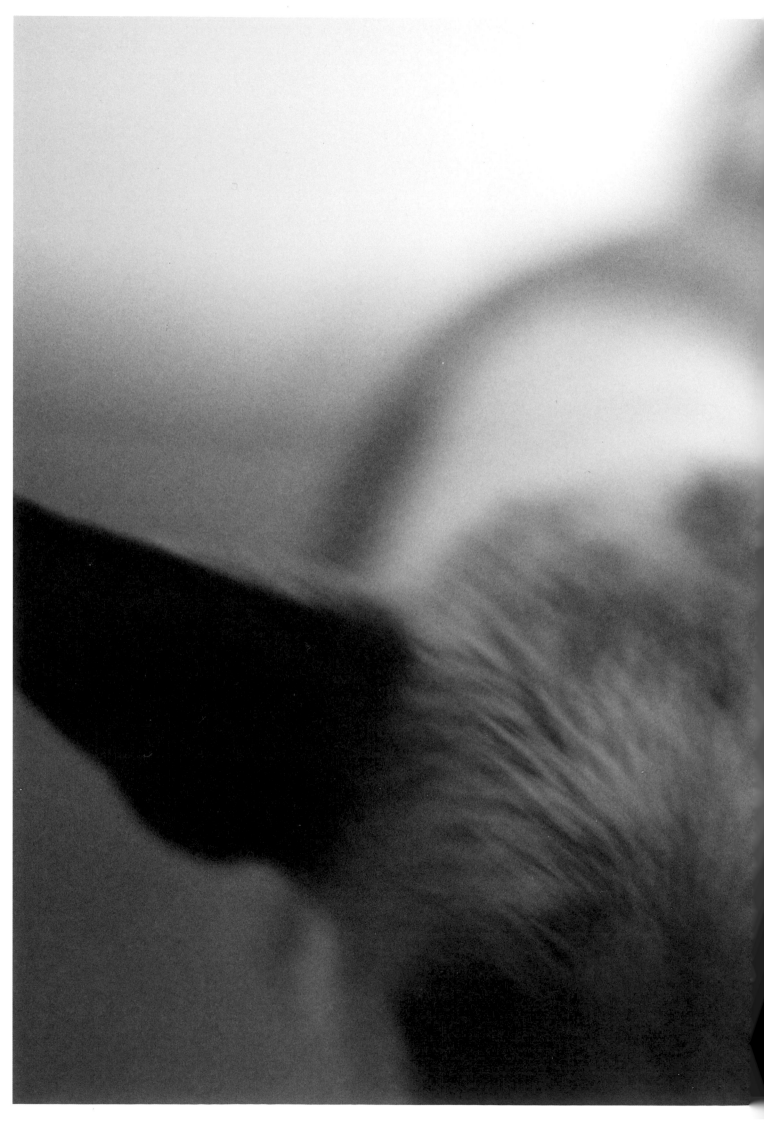

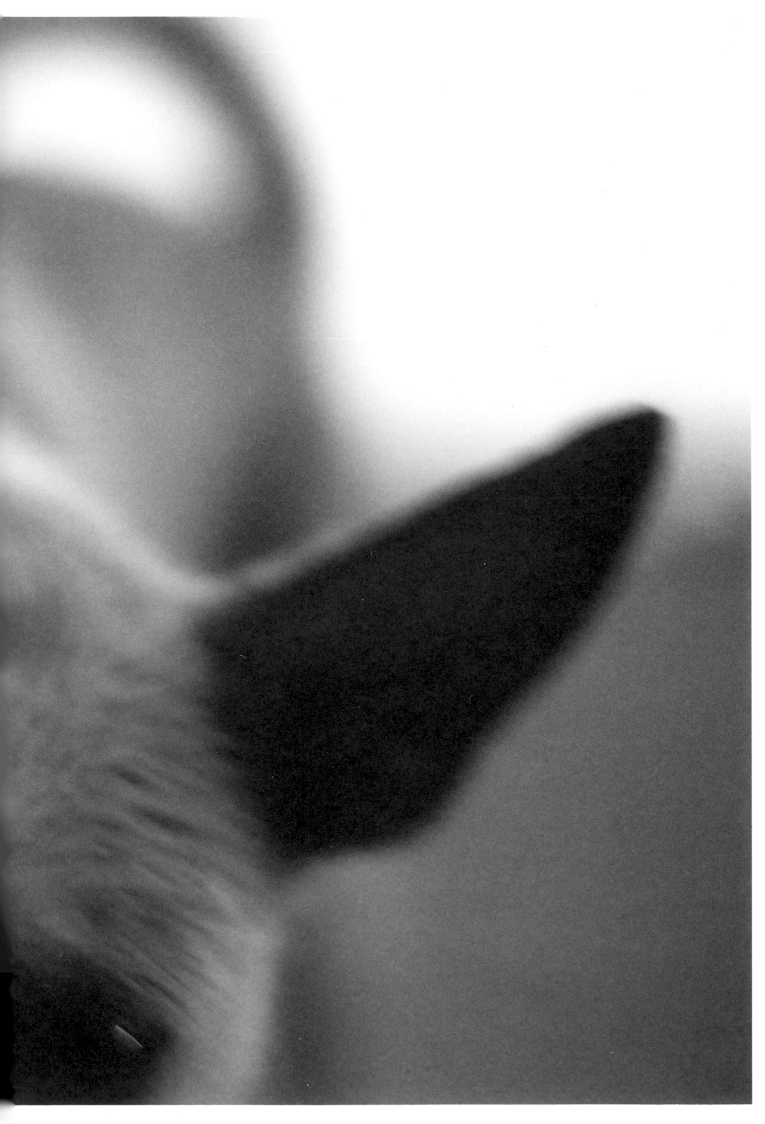

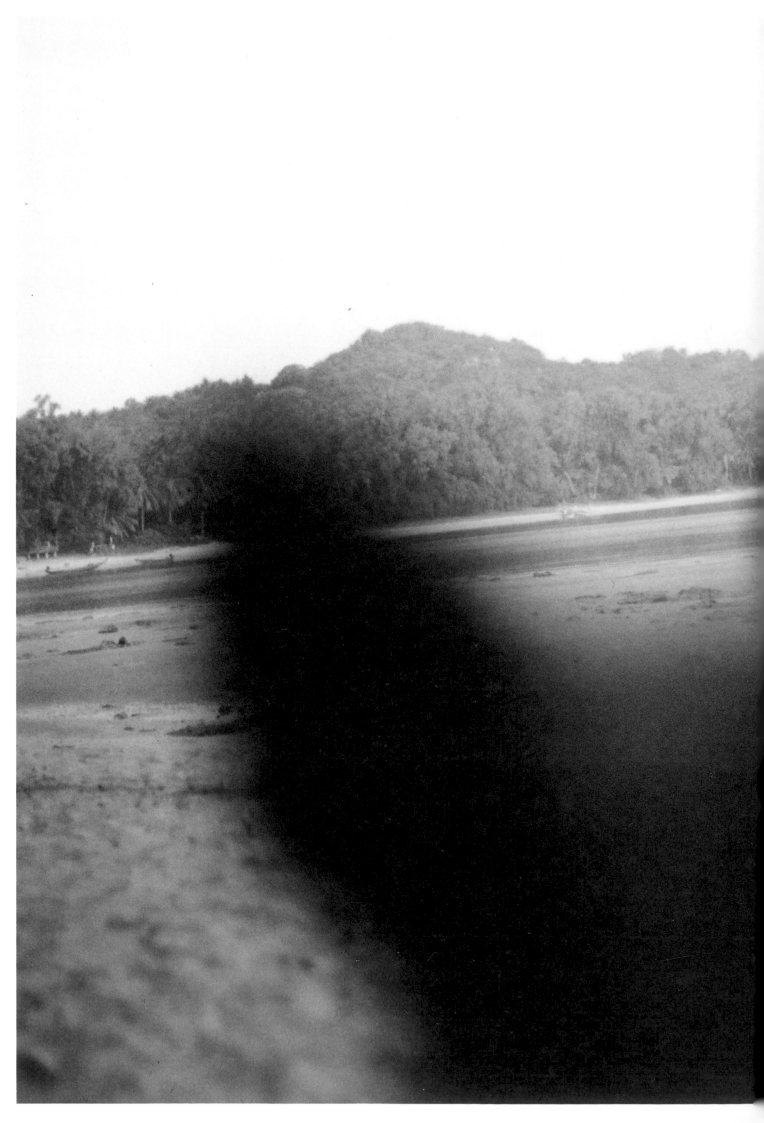

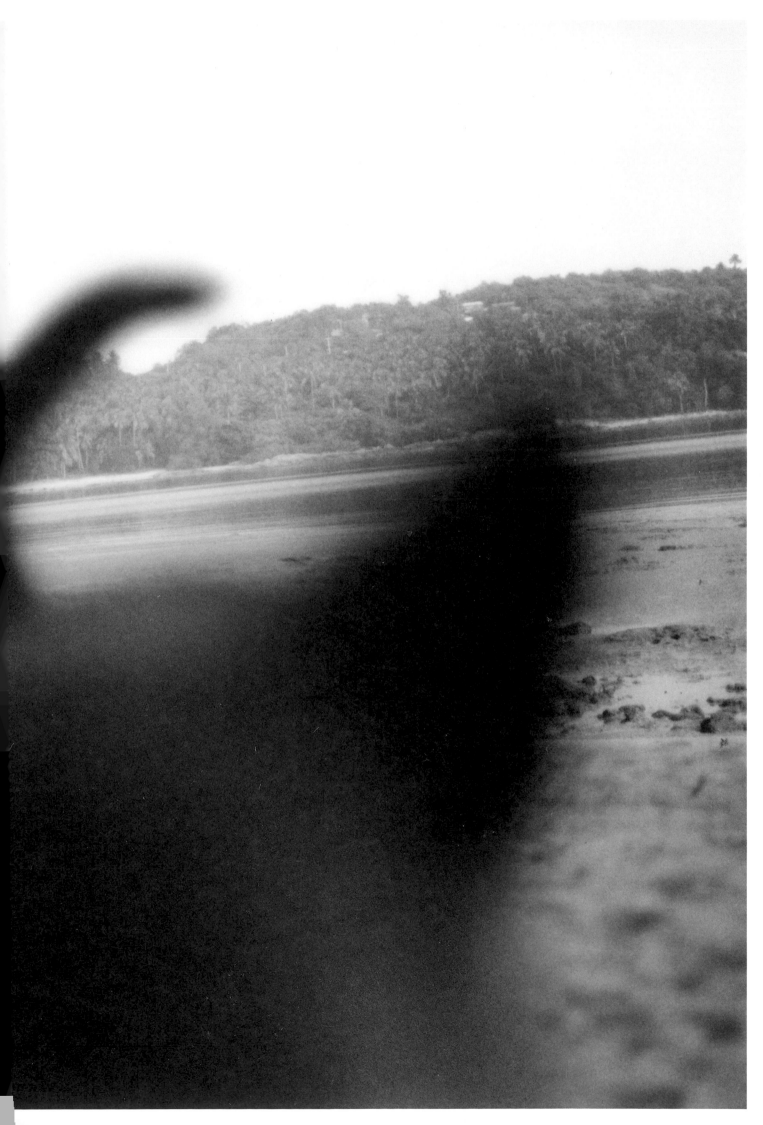

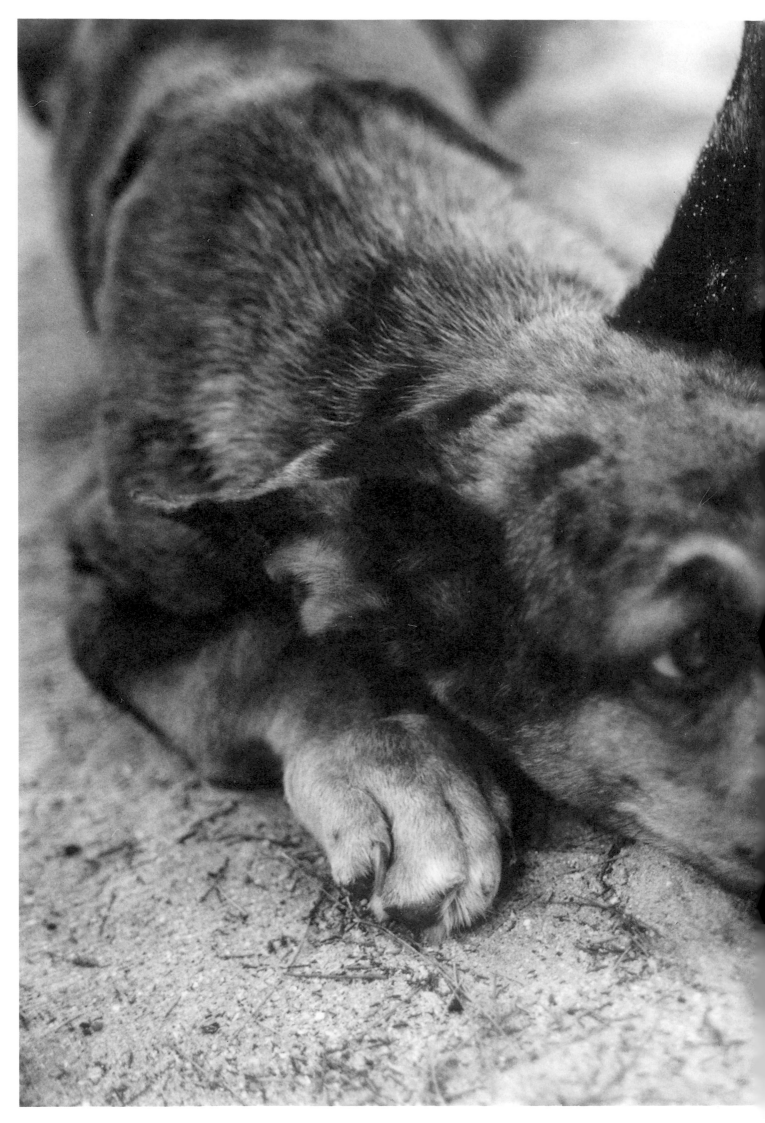

TWIN JADE PAGODA BRAND

Apply a rich lather of Twin Jade Pagoda Brand Camphor Soap each murning and night over body and face with fingertips or soft washcloth; massage the body and face throughly; Then rinse with luke warm water adding a cold splash of water to oily skin. This twice a day cleansing with Twin Jade Pagoda Camphor Soap will help to clear and smooth the skin, and because of its germcidal and antiseptic properties will protect the skin against infection of skin diseases. Use Twin Jade Pagoda Camphor Soap for its smoothing comforts, and its beneficial antiseptic rich lather which is effective and refreshes the skin.

可容用之。身當富消之洗。皂去林，無菌及。品唯一誠，及代現的純良。此中雙玉塔牌
保薊之涼爽滌去滑膩。皂去林需經水力特使殺實防人體百功科學砂加精選用國產純良。
膚緣保證如泡沫奇效數分鐘護膚用之。神而成，最新研制合產純皂。
珠壽早晚兩遍粗租時皂用之後者遇此後皂之。

"เจดีย์หยกคู่"

ผู้ใช้ผลิตผลสมุนไพรตรา "เจดีย์หยกคู่" เป็นสบู่ยี่ห้อผลิตจากยอดว่ยา และผลิตจากสมุนไพรตรา "เจดีย์หยกคู่" ผลิตจากยอดว่ยา

ด้วยกรรมวิธีและเครื่องปรุงโบราณ สมุนไพรผลิตผลสมุนไพรตรา "เจดีย์หยกคู่" ทำให้เราไม่ต้องกลัว

จากแพทย์หรือผลิตภัณฑ์เคมีสมัยใหม่ แต่จะใช้ให้ไม่ประจำวันได้ทุกวัน มีพลอยากกินเป็นพิเศษ

สรรพคุณ ข้อยกตัวอย่างได้ว่า รายยืดอุดคำยากำ แก้โลกอุกเกลือน ก่อเป็นผื่น ก่อเกิดผดผื่น น้ำมูกยังไหมังหวด

ไม่ควรยากกว่าน ใช้ประจวำสามารถว่ายยืดออกให้โรคผิวหนองหัดได้ว่า โดยคิว

ใช้ผลิตผลสมุนไพร "เจดีย์หยกคู่" ล้างหน้าหรือผิวออกว่า ก่อไว้ประมาณ 1-2 นาที

วิธีใช้

ผู้แทนจำหน่าย
............. รวกถนนเจริญนคร 1575/16-17 ถนนเจริญนคร ซอย 37 เขตคลองสาน กทม. 10600 โทร. 4393666

(handwritten) Sweet Joey eats the caterpillar

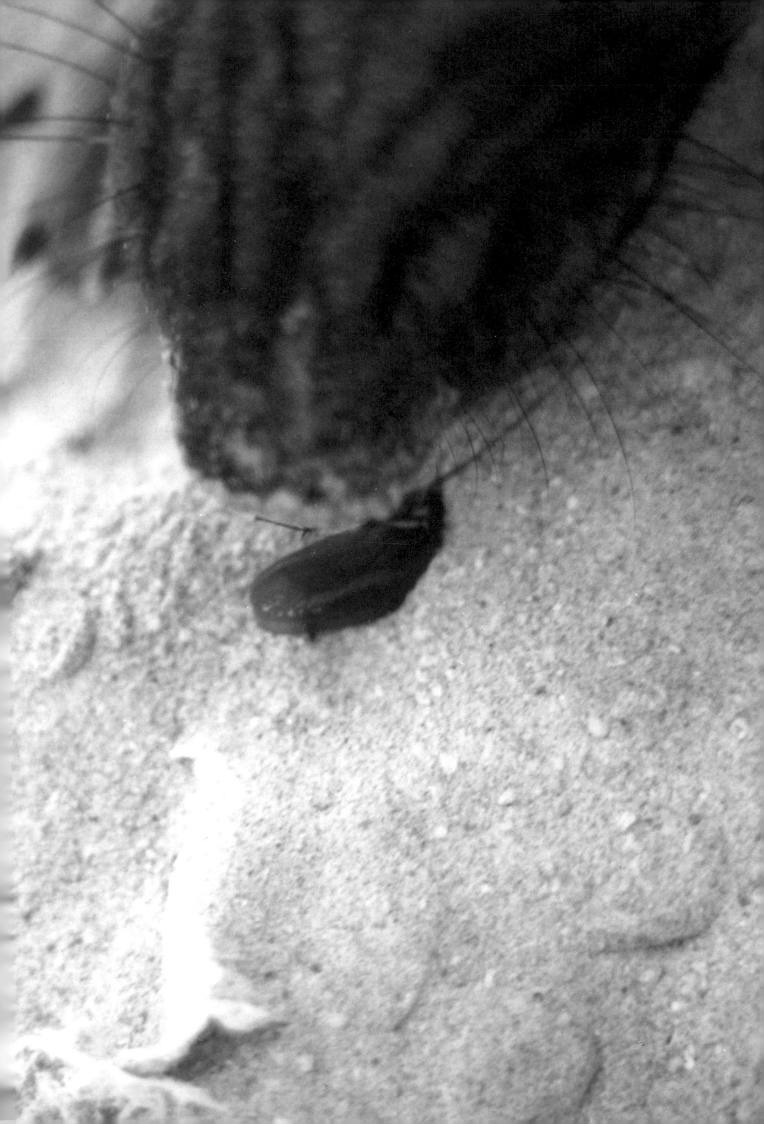

draft singha is better
than export.
— it only leaves a
slight formaldehyde
aftertaste.
— Two more. singha please.

ROOM

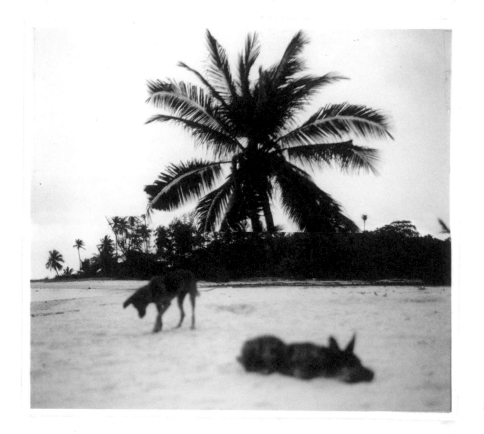

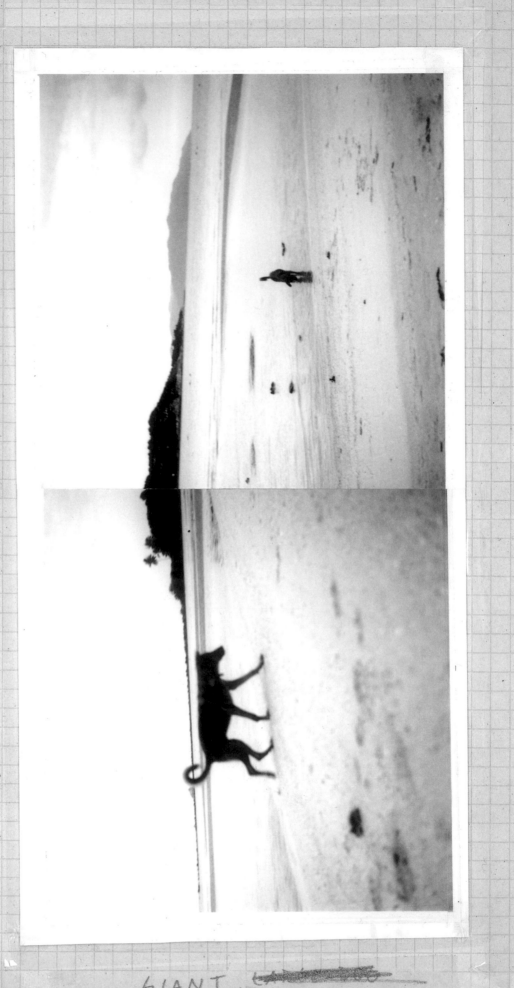

GIANT,

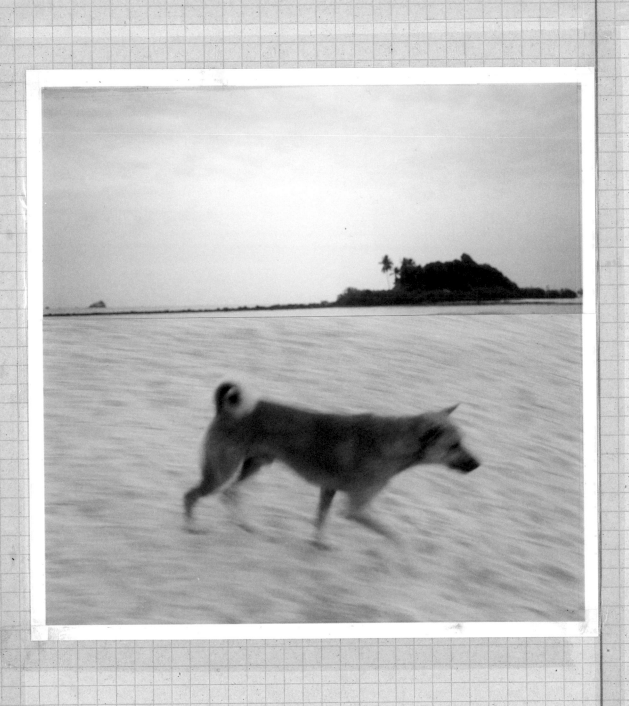

^ 473 DAYS : NO WIND , NO SUN .

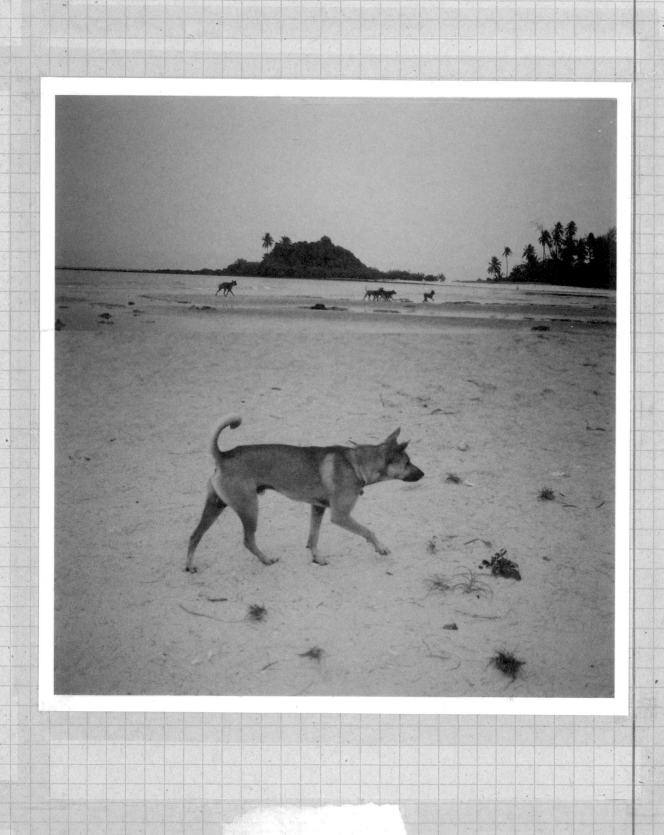

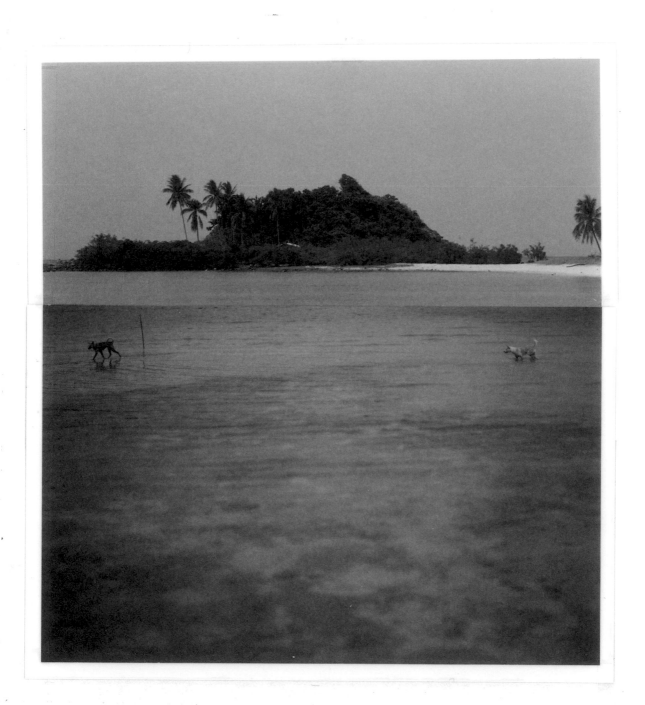

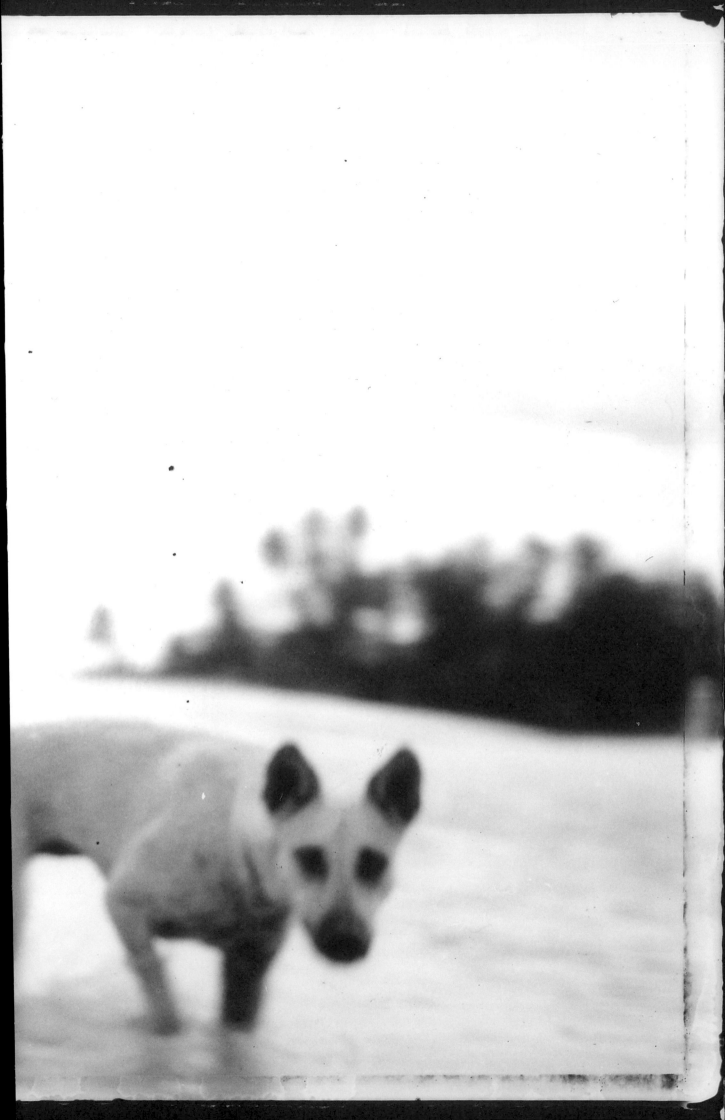

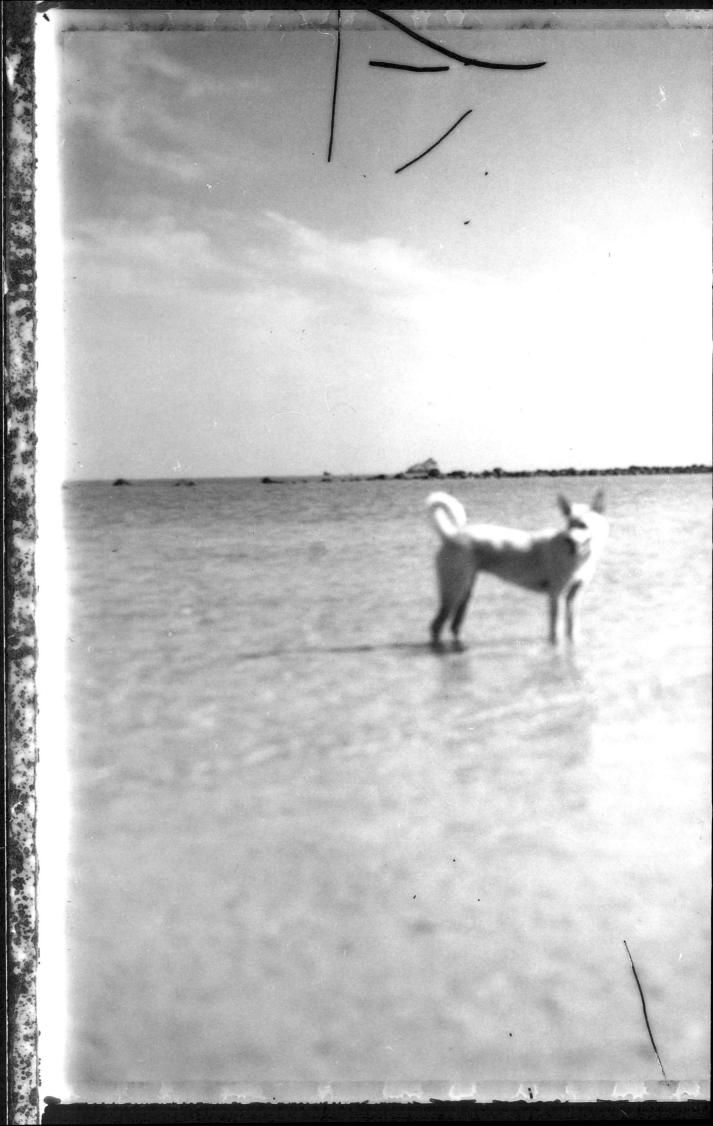

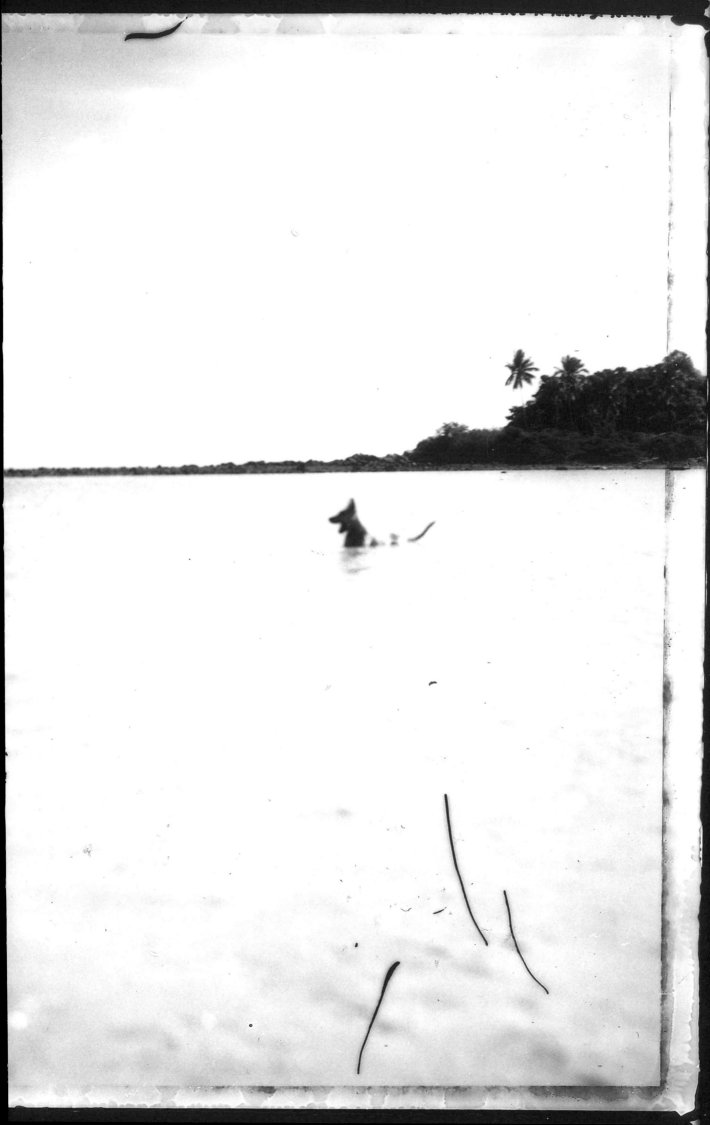

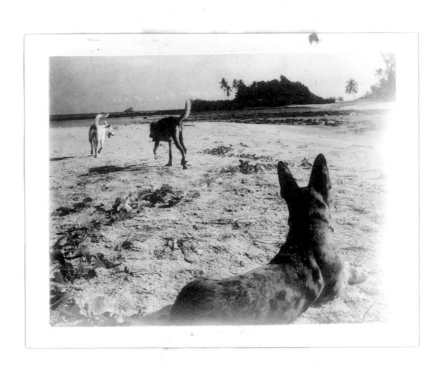

DAY #9

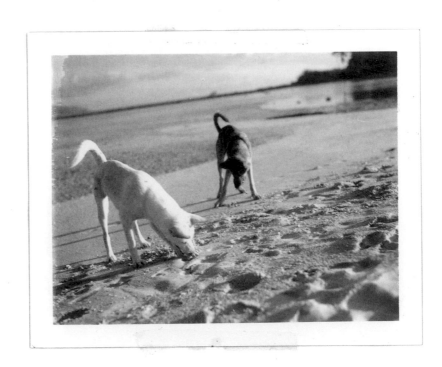

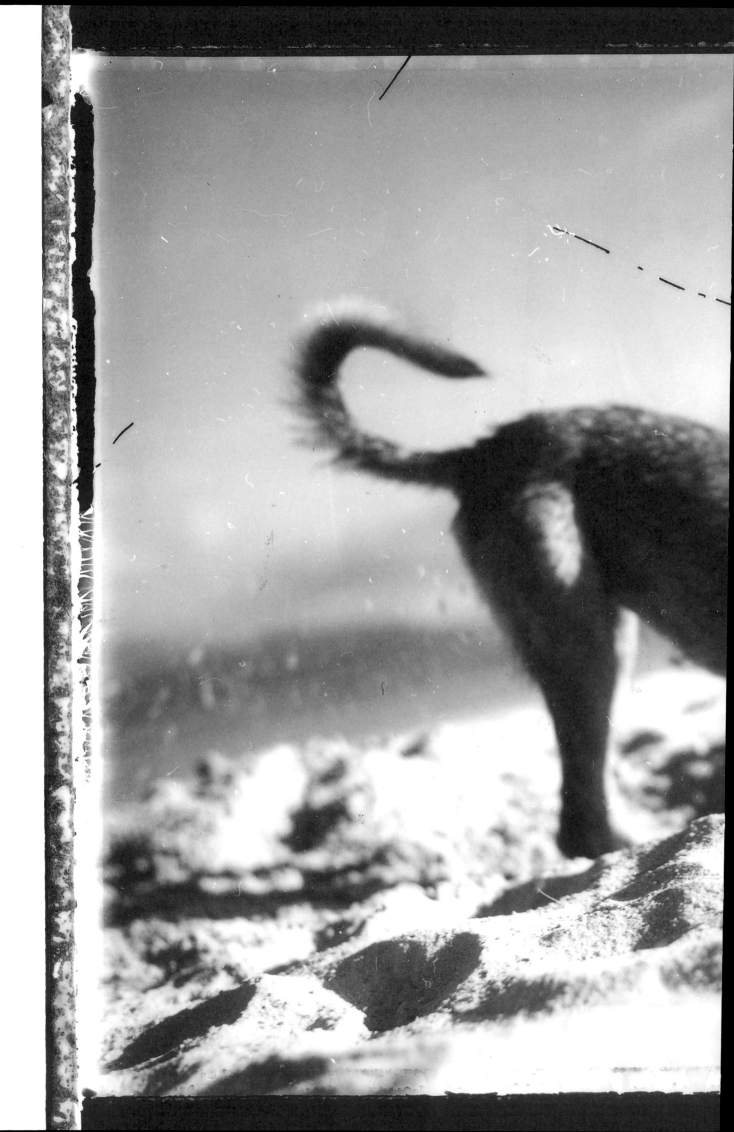

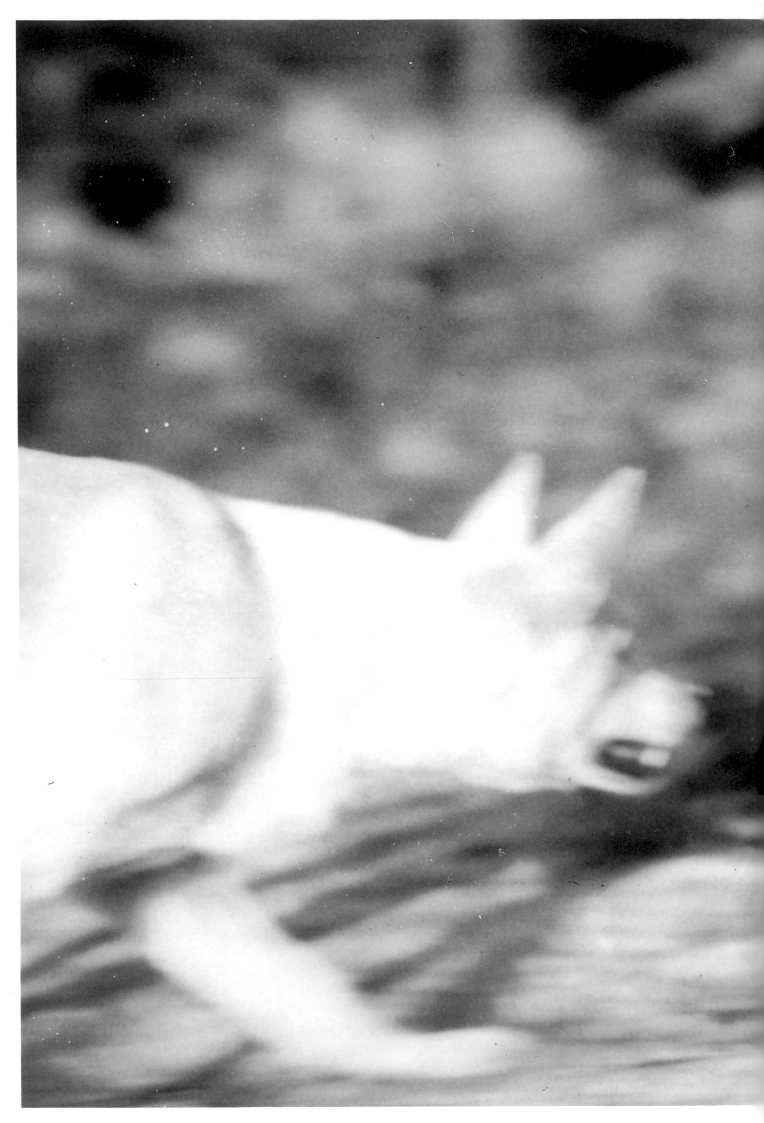

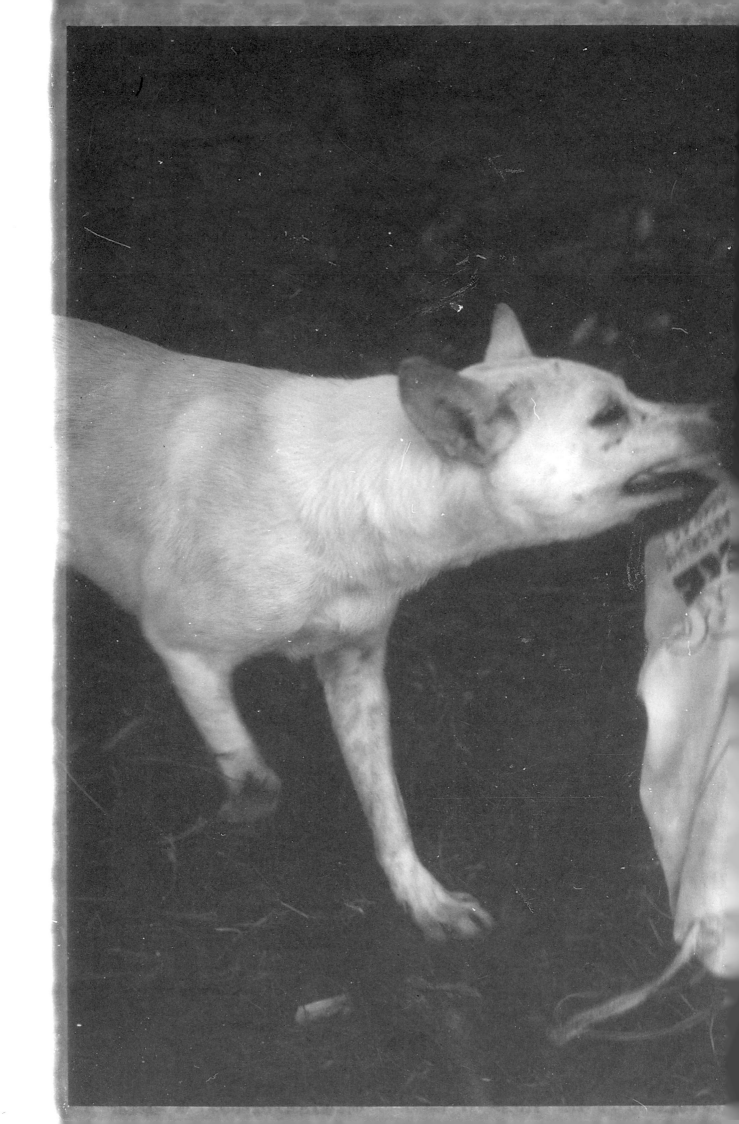

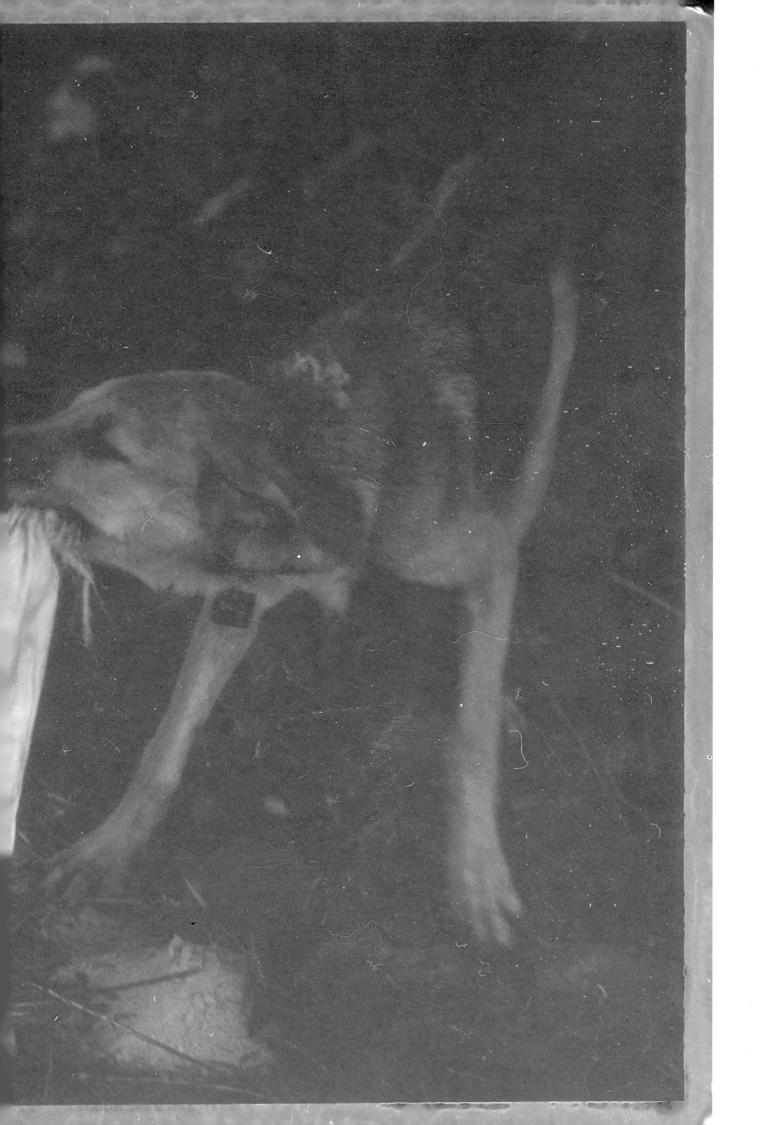

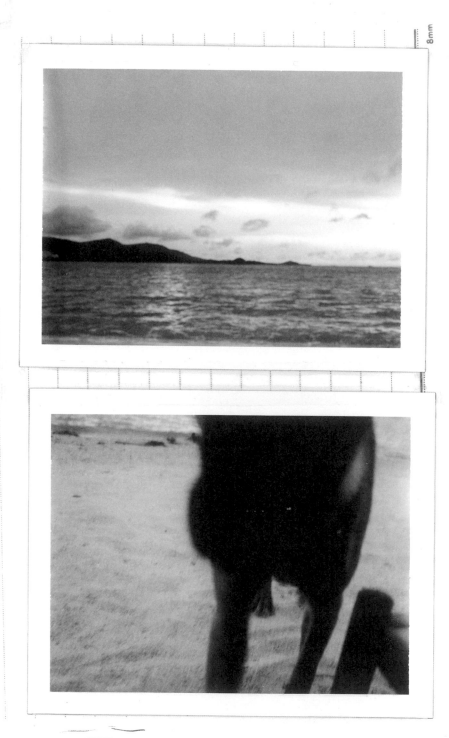

Caution. ✋

Sunday. Rain. Banana Porridge, Tea. 9 30
 2 omelettes, 1 coffee 12 20
 french fries, singha 16 00

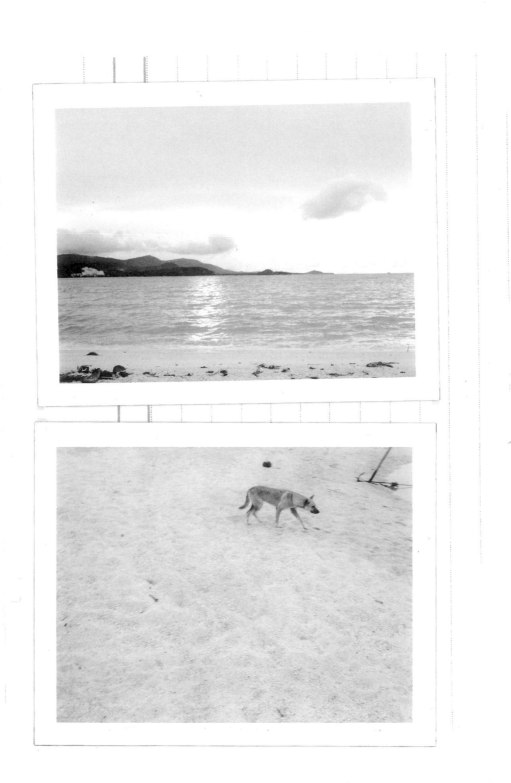

14

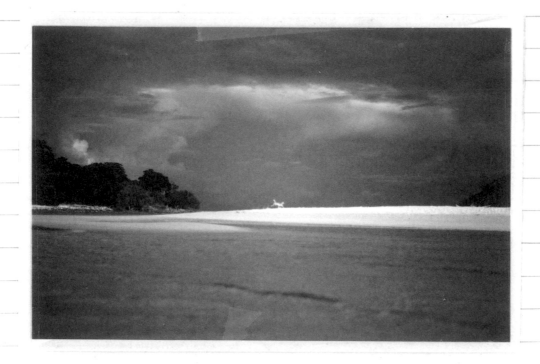

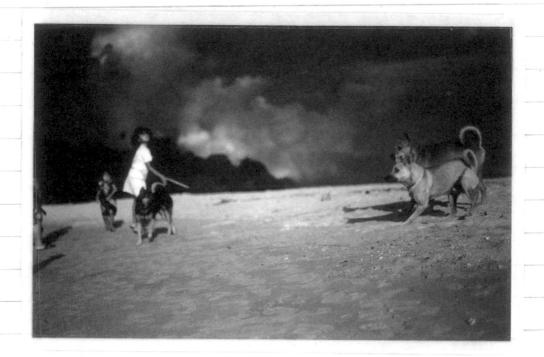

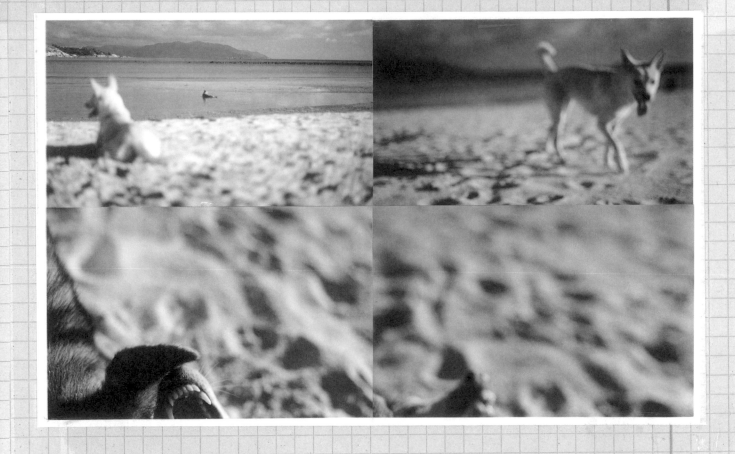

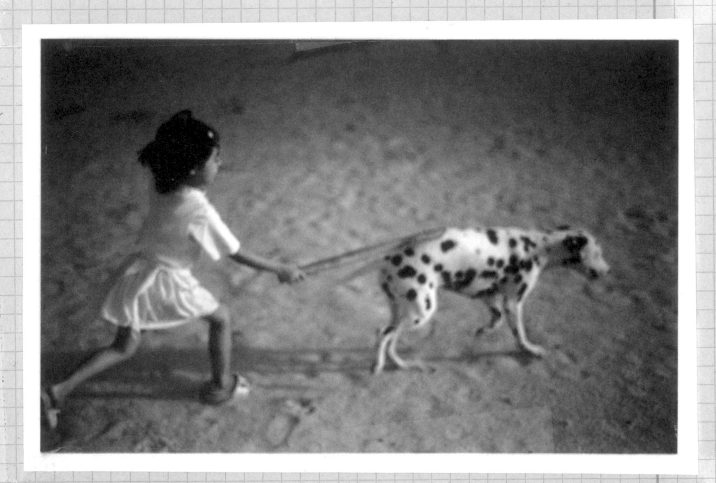

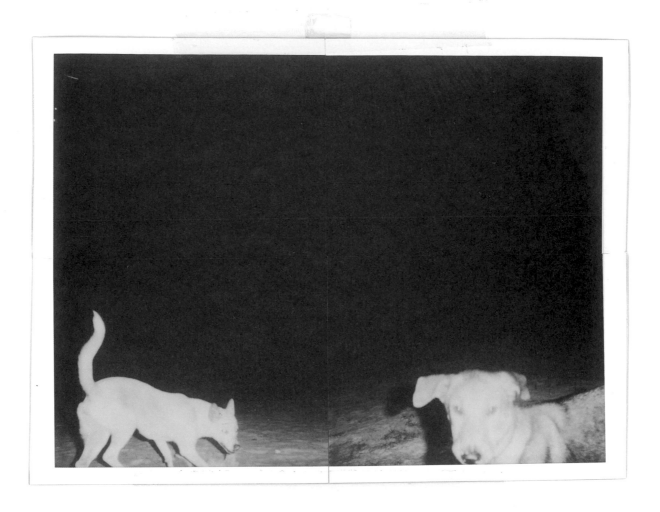

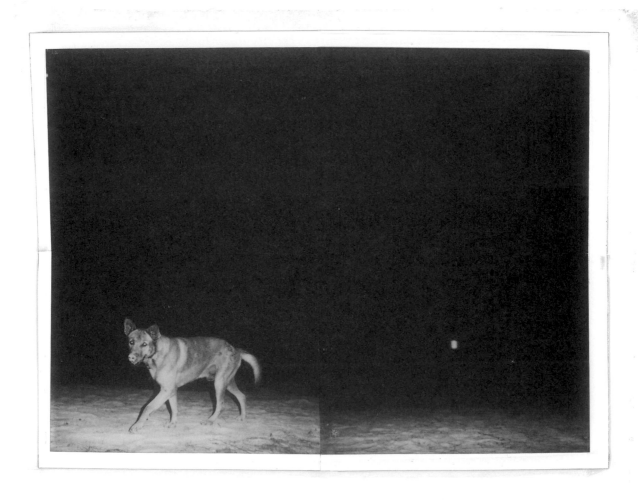

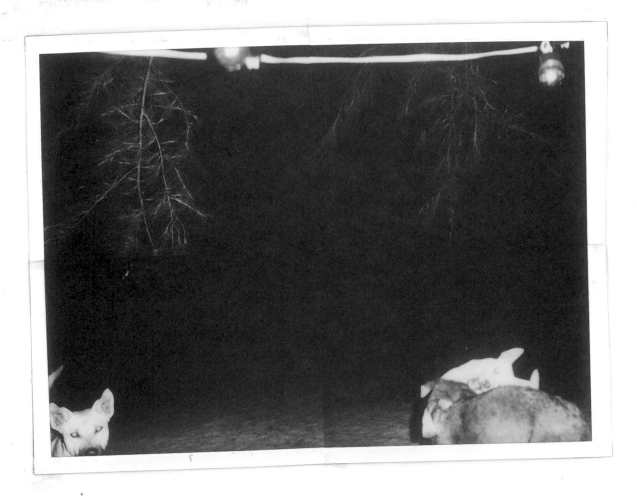

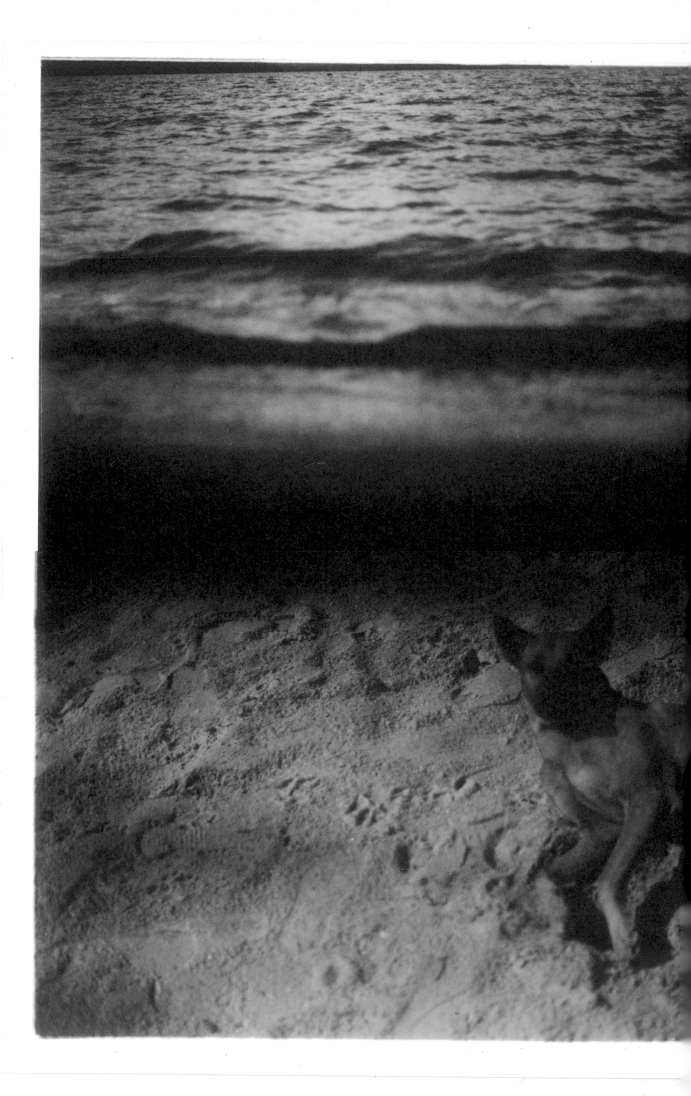

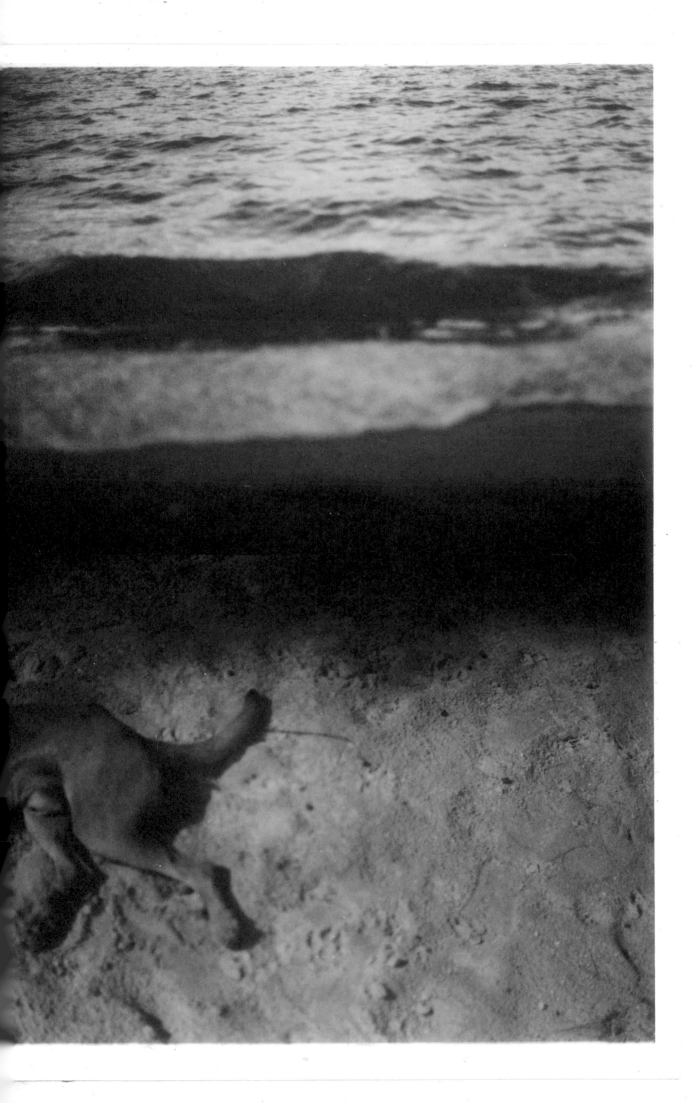

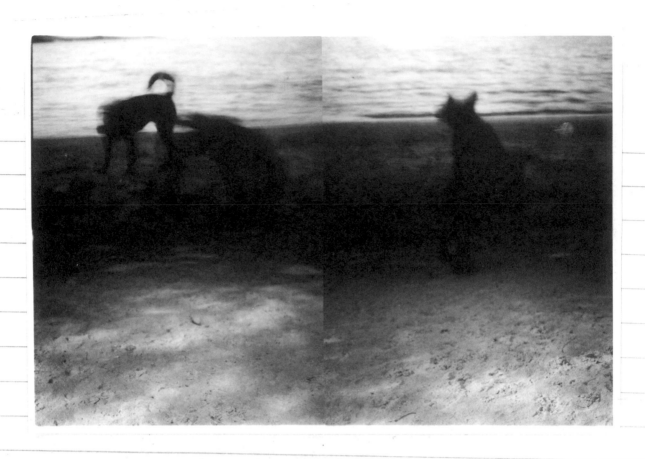

16

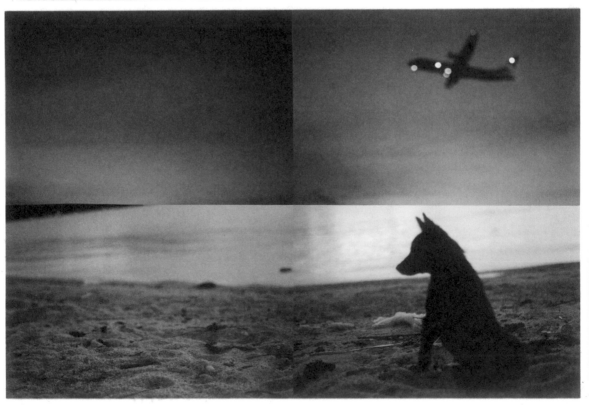

another plane ↑

BANGKOG AIR

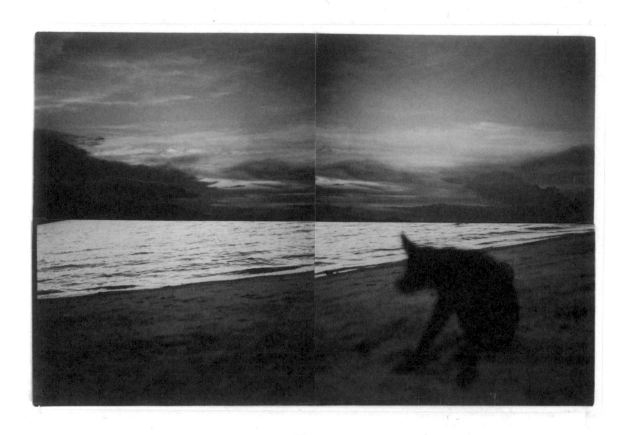

17

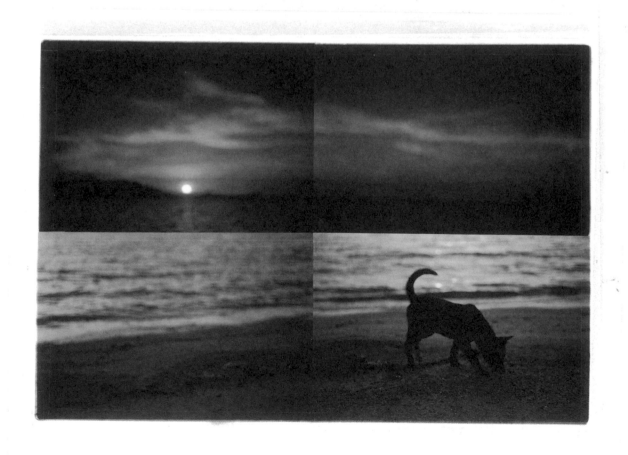

八月

A flying insect,

the size of a Tennisball,

hoovers 20 cm above the Floor.

it looks harmless.

Suddenly there is a big

SPLASH and the thing
flies off, leaving an
enormous spot of shit
behind.

12 วันเฉลิมพระชนมพรรษา
 สมเด็จพระนางเจ้าฯ พระบรมราชินีนาถ

17 เทศกาลสารทจีน

CRAB HOLE
CRAP HOLE

VICIOUS, BITING,
POISONOUS ANT
DEAD

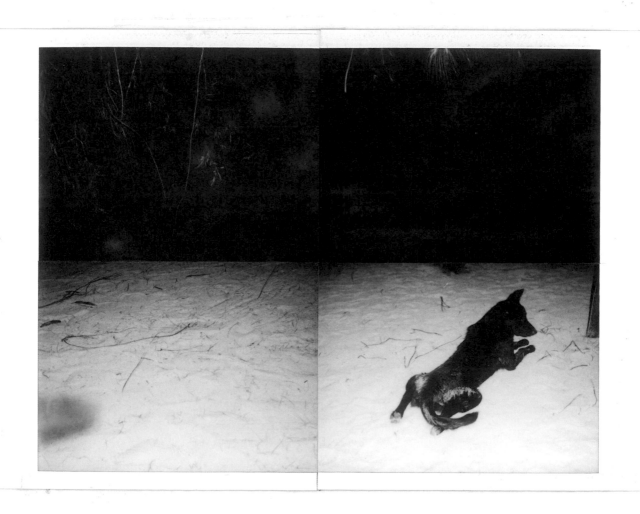

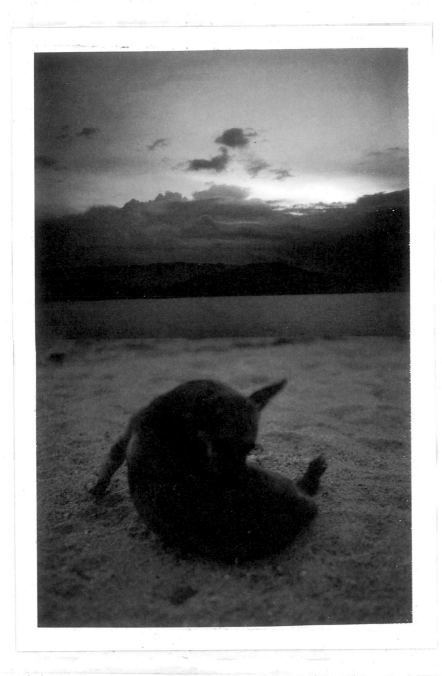

100 words for sand.

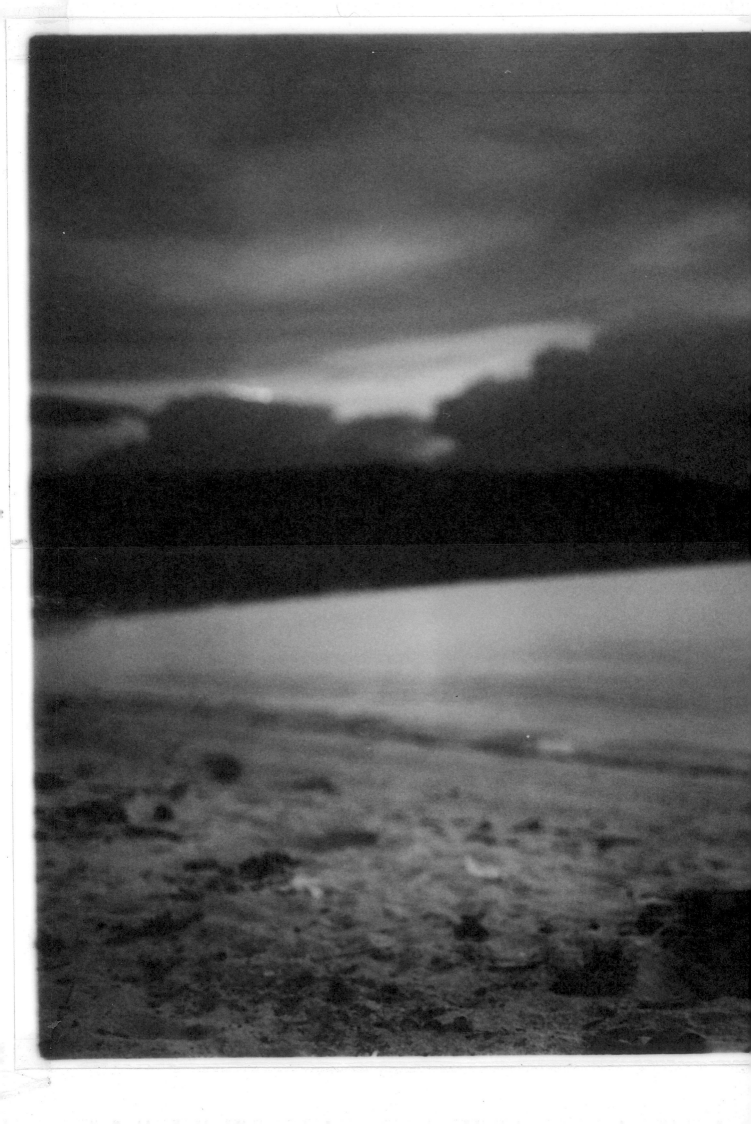

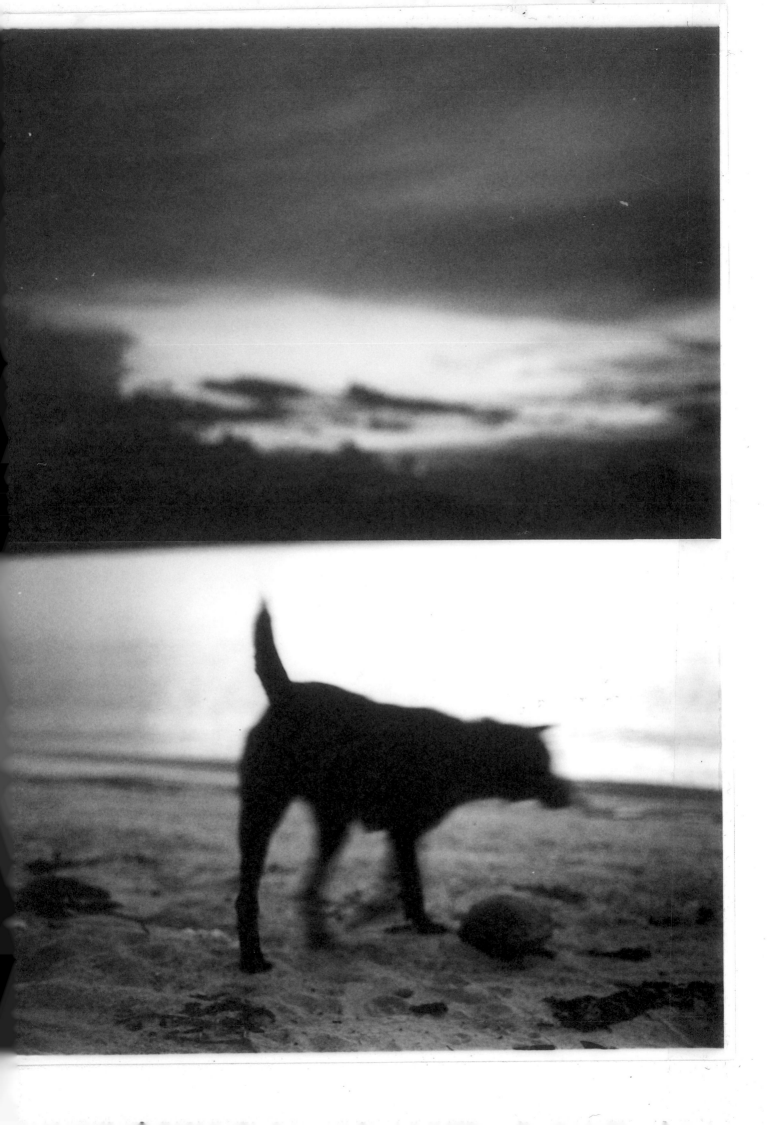

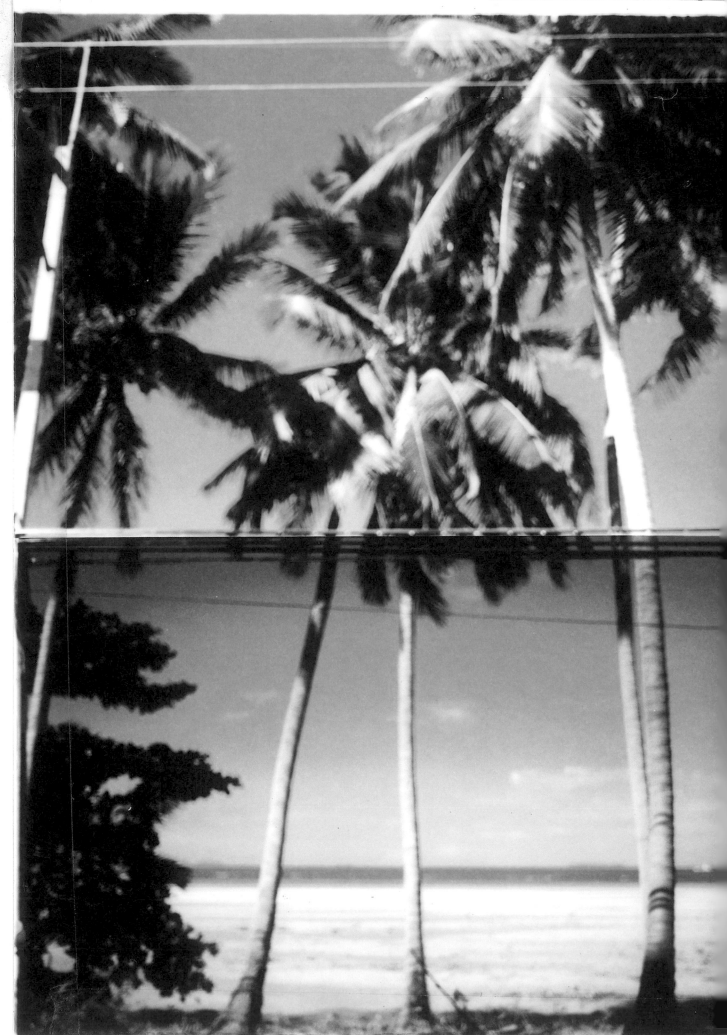

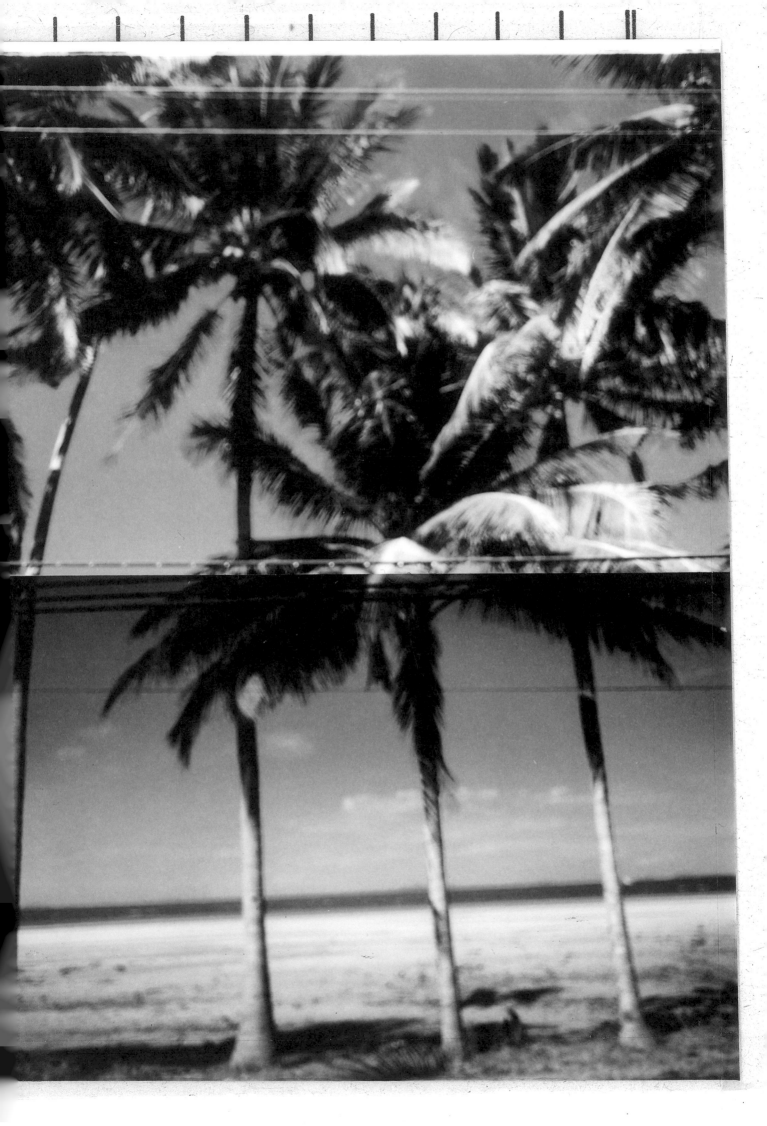

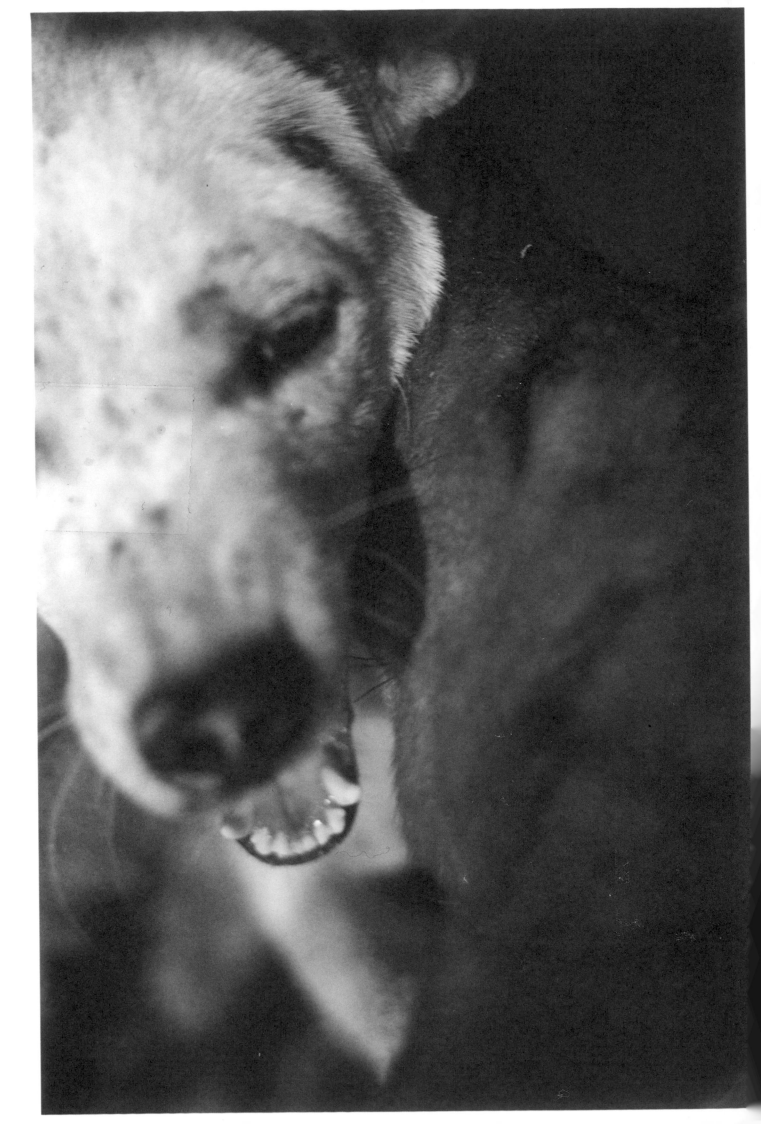

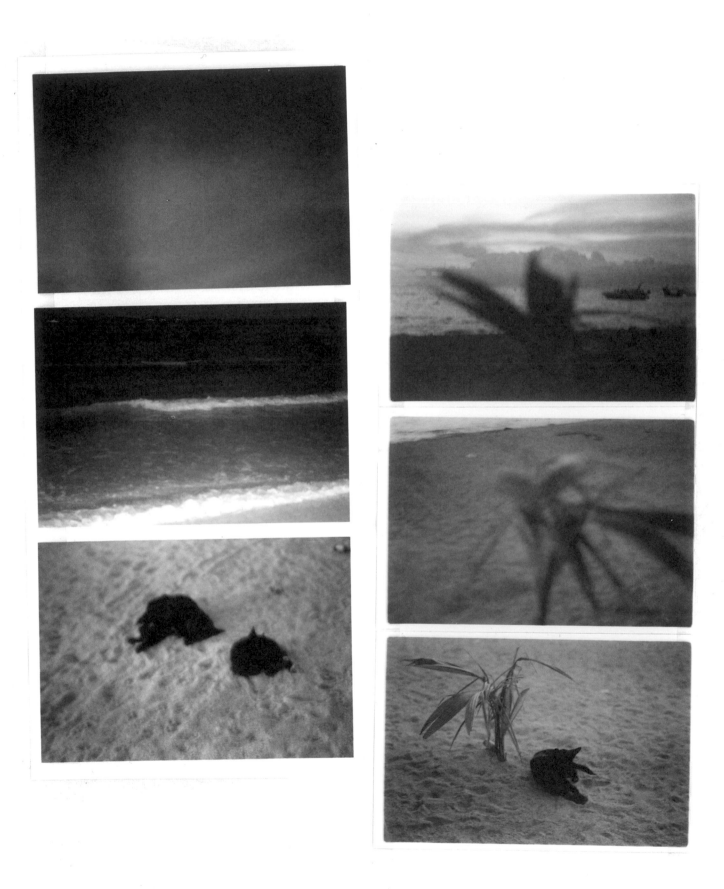

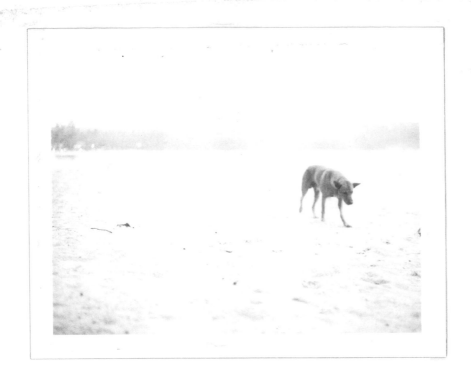

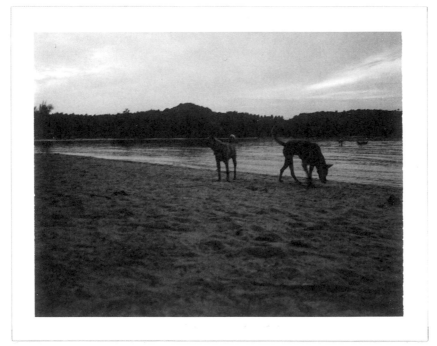

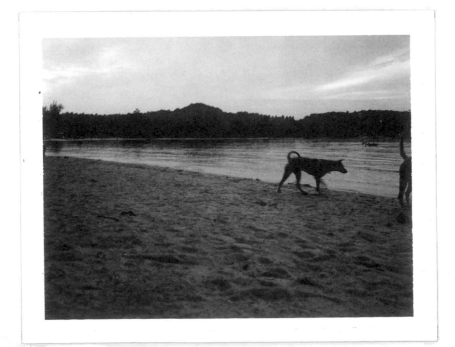

FEIERABEND
Celebration Evening

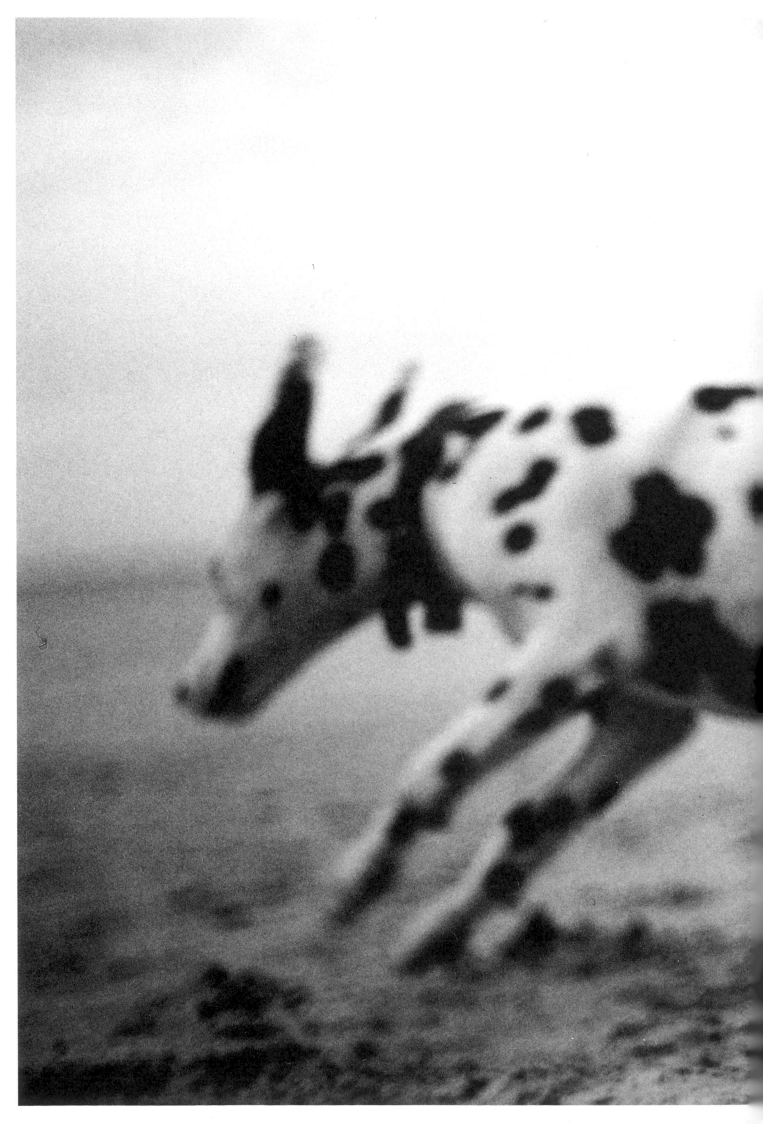

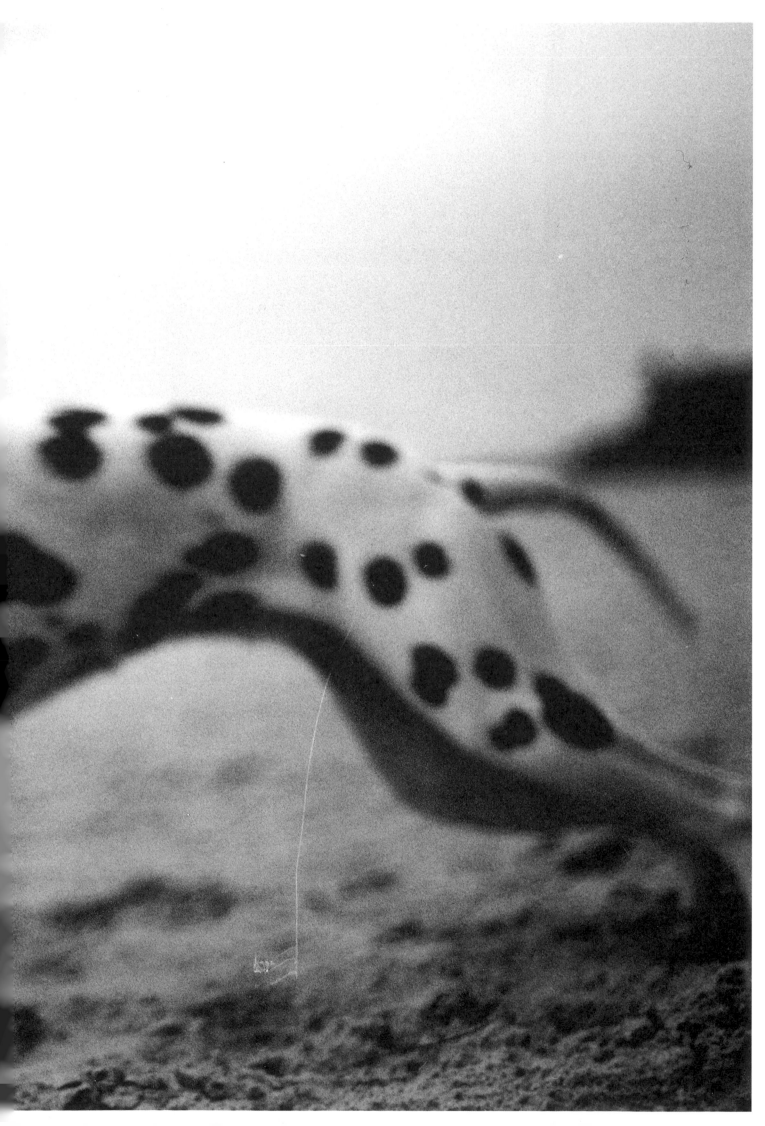

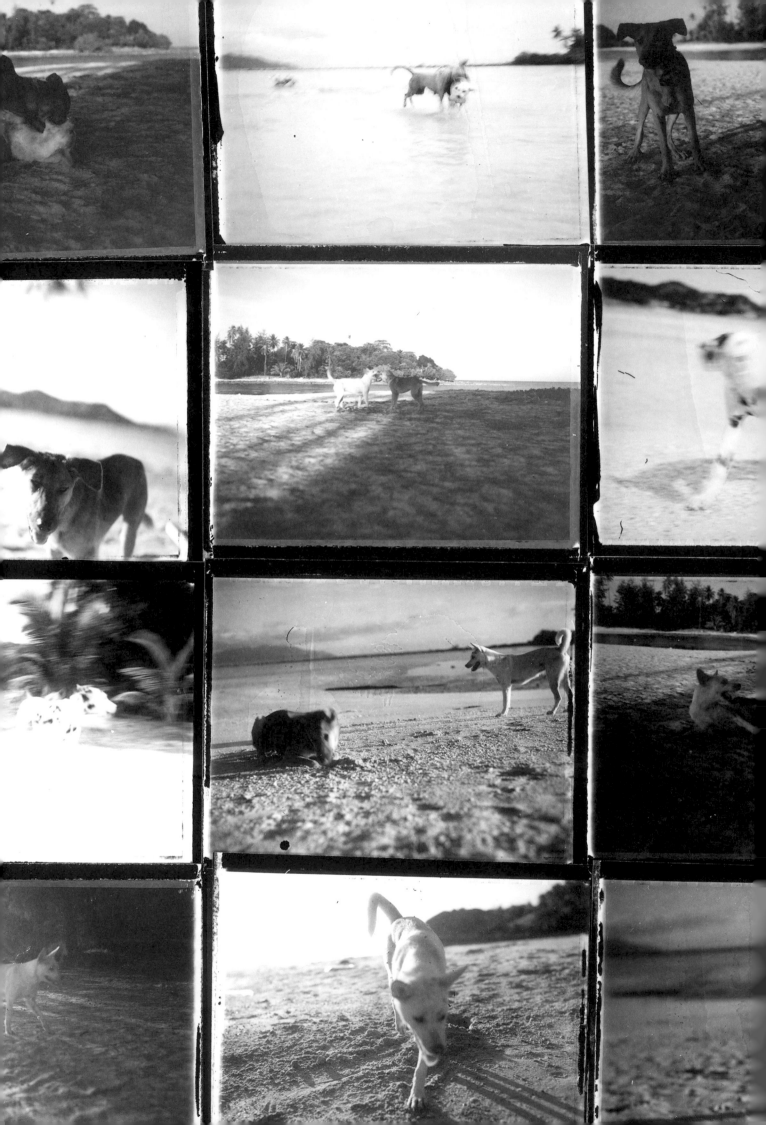